ANDY WARHOL

SUPE

RNOVA

STARS, DEATHS, AND DISASTERS 1962–1964

DOUGLAS FOGLE
WITH ESSAYS BY FRANCESCO BONAMI AND DAVID MOOS

WALKER ART CENTER, MINNEAPOLIS

COPYRIGHT

This catalogue is published on the occasion of the exhibition *ANDY WARHOL / SUPERNOVA: Stars, Deaths, and Disasters, 1962–1964*, organized by Douglas Fogle for the Walker Art Center.

—Walker Art Center, Minneapolis
November 13, 2005–February 26, 2006

—Museum of Contemporary Art, Chicago
March 18–June 18, 2006

—Art Gallery of Ontario, Toronto
July 8–October 1, 2006

National sponsorship of *ANDY WARHOL / SUPERNOVA: Stars, Deaths, and Disasters, 1962–1964* is provided by Northern Trust Corporation.

Additional support for the exhibition has been provided by Karen and Ken Heithoff, Miriam and Erwin Kelen, Joan and John Nolan, and Margot Siegel.

Library of Congress Cataloging-in-Publication Data

Fogle, Douglas, 1964-
 Andy Warhol/Supernova : stars, deaths, and disasters, 1962-1964 / Douglas Fogle ; with essays by Francesco Bonami and David Moos.-- 1st ed.
 p. cm.
 Includes bibliographical references.
 ISBN-13: 978-0-935640-83-0 (hardcover : alk. paper)
 ISBN-10: 0-935640-83-5 (hardcover : alk. paper)
 1. Warhol, Andy, 1928---Exhibitions. 2. Celebrities--Portraits--Exhibitions. 3. Biography--20th century--Portraits--Exhibitions. I. Bonami, Francesco. II. Moos, David. III. Title.
 NE2237.5.W37A4 2005
 769.92--dc22
 2005026961

DESIGNERS
—Andrew Blauvelt, Scott Ponik
EDITOR
—Karen Jacobson
PUBLICATIONS MANAGER
—Lisa Middag
CURATORIAL ASSISTANT
—Yasmil Raymond

Printed in the USA by Diversified Graphics Incorporated, Minneapolis
Color separations by Professional Graphics Inc., Rockford, IL

CONTENTS

FOREWORD ———————————— 7
Kathy Halbreich

ACKNOWLEDGMENTS ——————— 8

SPECTATORS AT OUR OWN DEATHS ——— 11
Douglas Fogle

PAINTINGSLAUGHTER ——————— 20
Francesco Bonami

ANDY WARHOL, PAINTER ————— 29
David Moos

PLATES ——————————————— 40

PLATE LIST ————————————— 106

SPONSOR'S STATEMENT ——————— 111

FOREWORD

Working in a wide range of media—including painting, sculpture, photography, film, drawing, and printmaking—Andy Warhol developed artistic methods and a conceptual approach that have been singularly influential. Intimately involved in the genesis of Pop Art in New York, Warhol created a body of work spanning three decades that persistently addressed American culture's often unexamined fascination with the surface of things as well as the darkness that usually lies below, say, the polished veneer of a celebrity's smile. *ANDY WARHOL/SUPERNOVA: Stars, Deaths, and Disasters, 1962–1964* brings together twenty-six major paintings from a cataclysmic period in American history and captures Warhol's first embrace of the seemingly dispassionate and distinctly modern process of the silkscreen, which he used to lift "hot" images directly from the media and coolly transfer them to canvas. Taking to heart his own declaration that he wanted to be a machine, Warhol adopted a mechanical method of painting as well as an approach that buried forever the traditional primacy of the artist's individual touch and pursuit of originality. The initial chill of this method created a terrifying equation: the bonsai-like glamour of iconic Hollywood stars merged with the everyday anonymity of "disasters" such as car wrecks and suicides. The implications of these seminal early works by Warhol live on in the legacy of the artists who followed him in the 1980s, 1990s, and even today.

The Walker Art Center's relationship with the work of Andy Warhol began in 1967 with its inclusion in a group exhibition entitled *Banners and Tapestries*. It was one year later, in 1968, that then-director Martin Friedman made the Walker's first major Warhol acquisition by bringing his painting *Sixteen Jackies* (1964) into our permanent collection. At this time the Walker was among only a handful of major American art institutions to collect the work of this artist, who for years was overshadowed by other painters of his generation. This relationship has continued over the years as the Walker has added another three paintings, a sculpture, photographs, and numerous prints to its collection. Most recently the Walker has been fortunate to receive a gift from Kate Butler Peterson of a magnificent set of Warhol's sculptures of grocery cartons. In 1999 the Walker hosted the exhibition *Andy Warhol: Drawings, 1942–1987*, which was organized by the Andy Warhol Museum, Pittsburgh, and the Kunstmuseum Basel.

Significantly, Warhol's painting *Sixteen Jackies*, which pictures the widowed Jacqueline Kennedy before and after the assassination of the president, was acquired in 1968. That year was one of extraordinary political and social upheaval in the United States and Europe, and while Warhol would insist endlessly in interviews that his art was not meant to be overtly critical of American society, it requires a deliberate blindness not to see the persistent iconography of "race riots," car crashes, electric chairs, and suicides as mirroring a world fixated on violence and death. Similarly, the tragic or tumultuous lives of just about every celebrity he painted also point to the pernicious reality behind the artifice of smiles made for the camera. In 2005 we find ourselves inhabiting a world in which horrific images of news events are delivered to our television and computer screens virtually in real time, thanks to hyperlinked global media networks, making it more difficult for us to process and interpret what we see. Perhaps the works in *ANDY WARHOL/SUPERNOVA* can make us pause long enough to ponder how such an oversaturation of violent images forces us to act or freeze. Truly, these are history paintings for our age, even more incisive now than when they were made.

Like any exhibition of this scope and magnitude, *ANDY WARHOL/SUPERNOVA* would not be possible without the support of many generous contributors. National sponsorship of this exhibition has been provided by Northern Trust Corporation, which has a strong history of supporting cultural outreach. We are deeply grateful to Northern Trust for its partnership and commitment to artists such as Andy Warhol, who help us find common ground. Additionally, I would like to thank Karen and Ken Heithoff, Miriam and Erwin Kelen, Joan and John Nolan, and Margot Siegel for their friendship, which spans many years. Their support of this exhibition is but one indication of their affection for the Walker and their love of art that engages us deeply.

The Walker Art Center is privileged to share this exhibition with the Museum of Contemporary Art, Chicago, and the Art Gallery of Ontario, Toronto. I am grateful to Bob Fitzpatrick, Pritzker Director of the Museum of Contemporary Art, and Matthew Teitelbaum, director of the Art Gallery of Ontario, for supporting this project by becoming our partners on the exhibition tour. Their early commitment made it possible to realize our ambition for this project. I am also indebted to Bob for his assistance in fundraising.

Finally, I must thank Douglas Fogle, former curator at the Walker and now curator of contemporary art at the Carnegie Museum of Art, who conceived and organized this exhibition with what, over the eleven years we worked together, I came to know as his customary care, tenacity, and intelligence. Following Douglas's earlier exhibitions for the Walker, which explored such topics as new tendencies in painting and the history of conceptual photography, this Warhol exhibition is an appropriate (if poignant) summation of his time here and contributions to this institution. Yasmil Raymond, newly appointed assistant curator, assisted Douglas at every stage of this project, making invaluable contributions.

Kathy Halbreich
Director
Walker Art Center

ACKNOWLEDGMENTS

This exhibition would not have been possible without the generosity and the commitment of the many lenders who agreed to part temporarily with important works from their collections. Their readiness to lend provided an opportunity to bring together some of the greatest works by Andy Warhol from around the world, and I am eternally grateful for their trust and commitment to this project: Art Gallery of Ontario, Toronto; William and Maria Bell, Los Angeles; La Colección Jumex, Mexico; Daros Collection, Zurich; Stefan T. Edlis, Chicago; The Eli and Edythe L. Broad Collection, Los Angeles; GAM, Galleria Civica d'Arte Moderna e Contemporanea, Turin; Hirshhorn Museum and Sculpture Garden, Washington, D.C.; The Menil Collection, Houston; Museum für Moderne Kunst, Frankfurt; Museum Ludwig, Cologne; Museum of Contemporary Art, Chicago; The Rose Art Museum, Brandeis University, Waltham, Massachusetts; San Francisco Museum of Modern Art; The Sonnabend Collection, New York; The Stephanie and Peter Brant Foundation, Greenwich, Connecticut; Tate, London; and Walker Art Center, Minneapolis.

Exhibitions as ambitious as this are impossible without the generous support of individuals and institutions that are as committed to contemporary art as is the Walker Art Center. I would like to extend my heartfelt thanks to longtime Walker supporters Karen and Ken Heithoff, Miriam and Erwin Kelen, and Margot Siegel, not only for their financial contributions to this project but also for their years of dedicated support of the Walker Art Center. I am additionally grateful to Northern Trust Corporation for stepping forward with incredible enthusiasm to become the exhibition's major corporate sponsor in Minneapolis and Chicago.

After its presentation at the Walker Art Center, ANDY WARHOL/SUPERNOVA will travel to the Museum of Contemporary Art (MCA), Chicago, and the Art Gallery of Ontario (AGO), Toronto. My thanks go to both institutions for giving the exhibition such a warm reception and for allowing their curators to take the time to make such insightful contributions to this volume. At the MCA: Robert Fitzpatrick, Pritzker Director; Elizabeth Smith, James W. Alsdorf Chief Curator and deputy director for programs; Francesco Bonami, Manilow Senior Curator at Large; Tricia Van Eck, curatorial coordinator and curator of artists' books; and Jennifer Draffen, director of collections and exhibitions. At the AGO: Matthew Teitelbaum, director; David Moos, curator of contemporary art; and Iain Hoadley, manager, exhibitions and photographic resources. Further thanks are due to Francesco Bonami and David Moos for their thoughtful, challenging contributions to this publication. It was a great pleasure to read their particular interpretations of Warhol's early silkscreen works. Additionally, their commitment to this project has ensured that this exhibition will reach a broader audience.

Numerous individuals have been of great assistance in securing loans, conducting research, and locating images for the catalogue. I am especially grateful to Dieter Beer, CEO, and Marianne Aebersold, registrar, Daros Collection, Zurich; Jennifer Belt and Michael Slade at Art Resource, New York; Neal Benezra, director, San Francisco Museum of Modern Art; Jeanne Bickley at The Stephanie and Peter Brant Foundation, Greenwich, Connecticut; Michel Blancsubé at La Colección Jumex, Mexico; Felicia Cukier at the Art Gallery of Ontario; Jan Debbaut, director of collections, Tate, London; Matthew Drutt, chief curator, The Menil Collection, Houston; Joanne Heyler, curator, and Juliana Hanner, registrar, The Eli and Edythe L. Broad Collection; Barbara Gladstone at Barbara Gladstone Gallery, New York; Eliana Glicklich at Artists Rights Society, New York; Michael Green at the Museum of Contemporary Art, Chicago; Willard Holmes, director, Wadsworth Atheneum Museum of Art, Hartford; Antonio Homem, Jason Ysenberg, and Alma Egger at Sonnabend Gallery, New York; Udo Kittelmann, director, Museum für Moderne Kunst, Frankfurt; Kasper König, director, Museum Ludwig, Cologne; Raphaela Platow, acting director and curator, The Rose Art Museum, Brandeis University, Waltham, Massachusetts; Perry Rubenstein and Sylvia Chivaratanond at Perry Rubenstein Gallery, New York; Tom Sokolowski, director, and Gregory J. Burchard, rights and reproductions/photo services manager, Andy Warhol Museum, Pittsburgh; and Olga Viso, director, and Kerry Brougher, chief curator, Hirshhorn Museum and Sculpture Garden, Washington, D.C.

There is a constellation of people who assisted with the conceptualization and realization of this exhibition and publication. First and foremost, I would like to thank the staff at the Walker Art Center for their extraordinary support and involvement in this project. For this exhibition, registrar Elizabeth Peck served tirelessly as the guardian for these extraordinary artworks and expertly coordinated the collection and tour of the exhibition. David Bartley and Evan Reiter ably oversaw the packing and storage of the works. I am indebted to Cameron Zebrun, program services director, and his staff for their collective efforts on the exhibition installation, especially to Jon Voils, who has overseen the installation at the Walker with care and professionalism. I thank Christopher Stevens, development director, and Marla Stack, director of special projects fundraising, who devoted themselves to climbing a seemingly insurmountable financial mountain. I also thank Mary Polta, chief financial officer, for expertly choreographing the budget. Additional invaluable support was provided by Phillip Bahar, director, marketing and public relations, and Karen Gysin, associate director, public relations.

The design of this publication is the result of the unbridled creativity of design director and curator Andrew Blauvelt and designer Scott Ponik. Its production was industriously overseen by publications manager Lisa Middag, while independent editor Karen Jacobson thoughtfully and gracefully shaped the texts in this volume. In the Visual Arts Department, I am grateful to deputy director and chief curator Philippe Vergne, curators Joan Rothfuss and Siri Engberg, and assistant curators Elizabeth Carpenter and Doryun

Chong for creating an atmosphere that encourages creativity and risk taking. Administrative assistant Eileen Romain kept me on track with a thousand details. Visual Arts administrator Lynn Dierks arranged the exhibition tour. At my side throughout the development of the exhibition and catalogue was assistant curator Yasmil Raymond. With incredible organizational savvy, unfathomable patience, and an irreverent sense of humor, she made innumerable contributions to the project. When I left the Walker Art Center to take up my new position at the Carnegie Museum of Art, I was very much at ease knowing that the exhibition was in her capable hands. *Besos.*

 Lastly, I owe a huge debt of gratitude to director Kathy Halbreich and former deputy director and chief curator Richard Flood for their guidance and support not only with this complex exhibition but throughout my tenure at the Walker as well. I drank their Kool-Aid eleven years ago, and I haven't been the same since.

Douglas Fogle

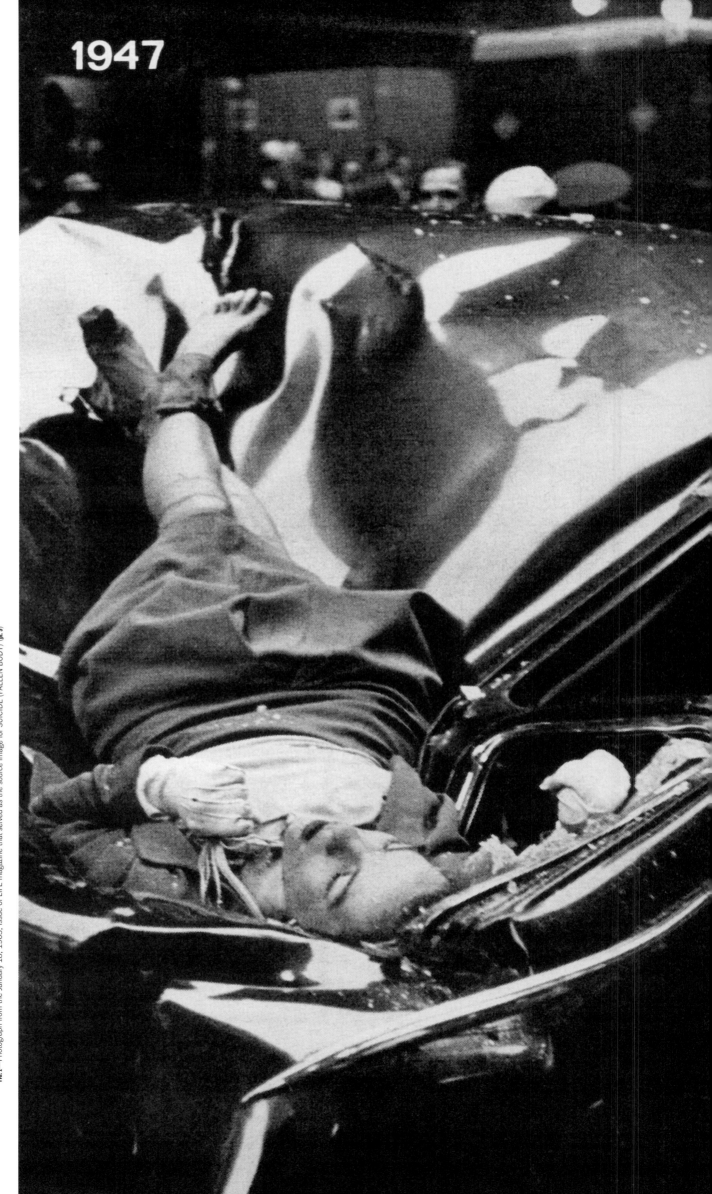

1947

FIG. 1—Photograph from the January 18, 1963, issue of LIFE magazine that served as the source image for SUICIDE (FALLEN BODY). (pl. 9)

Douglas Fogle

Spectators at Our Own Deaths

BEFORE I WAS SHOT, I ALWAYS THOUGHT THAT I WAS MORE HALF-THERE THAN ALL-THERE — I ALWAYS SUSPECTED THAT I WAS WATCHING TV INSTEAD OF LIVING LIFE. PEOPLE SOMETIMES SAY THAT THE WAY THINGS HAPPEN IN MOVIES IS UNREAL, BUT ACTUALLY IT'S THE WAY THINGS HAPPEN IN LIFE THAT'S UNREAL. THE MOVIES MAKE EMOTIONS LOOK SO STRONG AND REAL, WHEREAS WHEN THINGS REALLY DO HAPPEN TO YOU, IT'S LIKE WATCHING TELEVISION — YOU DON'T FEEL ANYTHING.

RIGHT WHEN I WAS BEING SHOT AND EVER SINCE, I KNEW THAT I WAS WATCHING TELEVISION. THE CHANNELS SWITCH, BUT IT'S ALL TELEVISION. *Andy Warhol*[1]

In her final book, Susan Sontag, who died in 2004, would revisit one of the most vexing questions posed by a culture that has been defined by its relation to the mediated image. In looking at historical as well as contemporary incarnations of the representation of death and suffering, especially in the field of war photography, *Regarding the Pain of Others* (2003) reconsiders the fundamental line of inquiry of her now-classic book *On Photography* (1977), in which she argued that the profusion of images of the calamities of war and violence would eventually blunt their impact on the spectator, making us callous. In her final publication she questioned this view: "As much as they create sympathy, I wrote, photographs shrivel sympathy. Is this true? I thought it was when I wrote it. I'm not so sure now. What is the evidence that photographs have

a diminishing impact, that our culture of spectatorship neutralizes the moral force of photographs of atrocities?"[2]

The same question has been posed again and again in relation to the work of Andy Warhol. In his early silkscreen paintings of stars, deaths, and disasters created between 1962 and 1964, we see an interesting case study for Sontag's query. As the artist himself even suggested, his own near-death experience after being shot in 1968 led him to a conclusion surprisingly similar to that of Sontag's earlier discussion of the numbing effect of harrowing images of disaster. After this experience, everything was like television, and life was viewed at a distance. Many critics over the years have been all too happy to dismiss Warhol's work as the product of precisely this kind of apathy.[3] But perhaps there might

11

1 — Andy Warhol, THE PHILOSOPHY OF ANDY WARHOL: FROM A TO B AND BACK AGAIN (New York: Harcourt, 1975), 91.
2 — Susan Sontag, REGARDING THE PAIN OF OTHERS (New York: Farrar, Straus & Giroux, 2003), 105. My sincere thanks go to my colleague Yasmil Raymond for suggesting the connection between Warhol's work and Sontag's essay.
3 — Not surprisingly, Sontag herself singles out Warhol in REGARDING THE PAIN OF OTHERS, calling him in a footnote "that connoisseur of death and high priest of the delights of apathy" (101n).

I guess it was the big plane crash picture, the front page of a newspaper; 129 DIE. I was also painting the Marilyns. I realized that everything I was doing must have been Death.

be a way of rethinking this view of Warhol's work along the lines of Sontag's revisionist rethinking of her own earlier position. Are we all simply just passive spectators at our own deaths?

Warhol's embodiment of Sontag's dilemma is wrapped up with what we might call the artist's multiple deaths. When exactly did Andy Warhol die? It seems like a simple enough question to answer. As the historical record would have it, the artist was pronounced dead in the early morning hours of Sunday, February 22, 1987, in a private room at New York Hospital on Manhattan's Upper East Side. Warhol had entered the hospital the previous day in order to have his infected gallbladder removed. Sometime early on Sunday morning the king of Pop Art succumbed to heart failure, leaving behind a massive estate and an artistic legacy of incredible depth and radical innovation.

Our question becomes more complicated, however, if we take to heart Warhol's description of his near-death experience after his shooting in 1968. The culprit was Valerie Solanas, the self-styled leader (and possibly only member) of the revolutionary feminist group SCUM, the Society for Cutting Up Men. On June 3, 1968, this occasional Warhol film actress and author of the *SCUM Manifesto* walked into the artist's studio and shot him with a .32-caliber pistol. Her stated motive was that she felt that Warhol had too much control over her life. Warhol bled profusely, and after he arrived at the hospital, his heart actually stopped beating, yet doctors were able to resuscitate the artist and went on to perform lifesaving surgery. As he himself stated, after that near-fatal incident, it was no longer possible to experience life

with the passion and engagement of a first-person perspective. Instead, his experience of life was now more akin to the passivity and sense of distancing associated with watching television. Perhaps, then, we can locate another, more metaphorical death for Warhol that dates from the moment when Solanas's bullet entered his torso, after which he became a spectator at his own slow march toward death.

Warhol was master of multiplication. Aside from his multiplied Marilyns, Lizes, Jackies, car crashes, and electric chairs, which he mechanically reproduced on his canvases using silkscreen technology, there was a sense in which the artist himself rivaled the biblical Legion. And if we heed the insights of the late critic Stuart Morgan, there were at least two Warhols. Writing in 1987, just before the artist's actual death, Morgan suggested that there was one Warhol who existed before his 1968 "accident" and another one, a doppelgänger Warhol, who took control of his career after this unfortunate event. He went on to suggest that in the Factory period (1963–1968), prior to his shooting, Warhol's work at every turn radically challenged the prevailing standards of contemporary artistic practice, calling into question acceptable notions of taste, technique, and subject matter. The same could not be said for the period dominated by the other Warhol. As Morgan suggested, "When he returned to work after the accident, nothing was the same."[4] This other Warhol was a celebrity and a businessman first while doubling as an artist by night, accepting commissions to paint portraits of the movers and shakers of high society and even agreeing to paint portraits of their dogs.

12

4—Stuart Morgan, "Andy and Andy, the Warhol Twins: A Theme and Variations," PARKETT, no. 12 (1987): 34–43.

This was a Warhol who had, in the mind of many commentators, abandoned his earlier critical edge regardless of the artist's repeated declarations that his work was neither critical nor edgy. It was this critical incarnation of Andy Warhol whose demise Morgan eulogized.

While there were many Warhols during the lifetime of the artist, in his afterlife there are an equally multifarious number of undead Warhols who inhabit the landscape of the critical and historical recounting of the artist's career. Some of these versions of Warhol get lost amid the blurred boundaries of the artist's persona and his work. In this case the literal death of the artist in 1987 dovetailed with the critical notion of the "death of the author," discussed by Roland Barthes in 1968, as Warhol's various bodies of work came unmoored from the weight of personal biography and began to drift along more free-floating trajectories, open to interpretations that might illuminate our present cultural situation.[5] Today one of those zombies, the post-Solanas celebrity Warhol, has faded somewhat from our line of sight. In its place is a Warhol who produced a critical body of work that might somehow allow us to more fully explore the ethical questions that Sontag raised regarding the use of images.

Looking at the history of Warhol's work through the lens of the present, it starts to become clear that in the artist's first groups of silkscreen paintings, begun in 1962 — his images of stars, deaths, and disasters — we find a historical corollary to contemporary visual culture, which has been branded by events — or, more importantly, the endlessly reproduced and transmitted images of events — most recently, the 9/11 terrorist attacks, the Abu Ghraib prisoner abuse scandal, and the tragic aftermath of Hurricane Katrina. How can these works, painted more than forty years ago, illuminate our present situation? What do they tell us about a culture in which disaster has become the staple of our televisual ways of seeing as the 24-7 coverage of tragedies on the cable news networks and the personal psychological train wrecks that are the basis of reality television become the equivalent of roadside accidents from which we can't avert our gaze? Can Warhol's paintings tell us something about our very own night of the living dead, in which we, like Warhol, have in effect become spectators at our own deaths?

In the summer of 1962, six years before his own near-death experience, Warhol became preoccupied with the subject of mortality. He took up the word *disaster* to describe his early silkscreen paintings from the fall of 1962 based on appropriated newspaper images of car crashes, suicides, and other lamentable events. (He would use this term again to describe his own shooting.) In an interview with Gene Swenson published in November 1963, the artist even went so far as to suggest that he was going to call his first solo exhibition in Europe *Death in America*. While the title was never used for his exhibition at Ileana Sonnabend's gallery in Paris in January of 1964 — which included examples of his suicide, electric chair, car crash, and "race riot" pictures — it was clear that for Warhol death and disaster were pervasive themes.

Of course, these terms could also be applied to some of his earliest paintings of celebrities, which were produced parallel to the officially designated Disaster pictures but were initiated a few months earlier. As Kynaston McShine has pointed out, "It was when the Disasters' theme of death coincided with his fascination with stardom and beauty that Warhol found the subjects of his best-known groups of celebrity portraits: Marilyn Monroe, Elizabeth Taylor, and Jacqueline Kennedy."[6] It is the convergence of Warhol's early fascination with images of anonymous deaths with what would turn out to be a careerlong interest in images of celebrities that leads me to think of these works as being cut from the same cloth. Our fascination with the beauty and glamour of celebrities seems to have an inevitable flip side, which is our deep-seated obsession with tragedy and death.

In fact, if we trace the etymology of the word *disaster*, we find a confirmation of McShine's revelation. Rooted in the notion that our lives are governed by the movements of the heavenly bodies, the word originally referred to an unpropitious aspect of a planet or star. In New York in the summer of 1962, Warhol, most likely unwittingly, began to explore the implications of this word as he turned away from his iconic hand-painted Pop images of things such as Campbell's soup cans and began using the photo-silkscreen process to open up a dialogue between celebrity and disaster. It was with the sad demise of the Hollywood superstar Marilyn Monroe that the artist initiated his investigation. He began producing images of Monroe just after her suicide on August 5, 1962, which occurred at the same time that he had independently begun making silkscreen paintings. His numerous paintings of the movie star, rendered in single and multiple formats, were all derived from an iconic black-and-white publicity image. In November of 1963 Warhol himself linked these images to the theme of death: "I guess it was the big plane crash picture, the front page of a newspaper; *129 DIE*. I was also painting the *Marilyns*. I realized that everything I was doing must have been Death. It was Christmas or Labor Day — a holiday — and every time you turned on the radio they said something like '4 million are going to die.' That started it. But when you see a gruesome picture over and over again, it doesn't really have any effect."[7]

In its insistent repetition of Monroe's image, Warhol's painterly investigation took on an almost pornographic quality. The fixation on the actress's face resulted in a large body of work, with more than fifty paintings executed between August 1962 and 1964. Among these are some of the artist's more monumental paintings, namely, the serial depictions of Monroe that he painted between August and September of 1962. *Marilyn Diptych* (1962; pl. 2) is perhaps the most iconic of these works. Composed of two large panels—each with twenty-five silkscreen repetitions of a publicity photograph rendered either in garish, oversaturated colors (orange, turquoise, red, black, and yellow) or in black and white—this painting constitutes a kind of altarpiece memorializing the fallen star as her repeated image shifts from color to obliteration and then a long, slow fade-out. Unique among this body of paintings is *Marilyn Monroe's Lips* (1962; pl. 3), an even more massive two-panel canvas that isolates the starlet's incredibly evocative lips and reproduces them 162 times, once again

5—Barthes argued that removing the function of authorial intentionality from our critical interpretation of literature—in other words, not trying to intuit "what the author meant"—opens up a text to a multiplicity of interpretations, leading necessarily to what he calls the birth of the reader. As he suggests, "the birth of the reader must be at the cost of the death of the author." Warhol's work embodies this concept in many ways but especially in relation to the appropriated character of his source imagery and the mechanical production process of the silkscreen painting technique. Additionally, he often did not make his paintings himself but left their execution to assistants such as Gerard Malanga. Interestingly, Barthes's essay "The Death of the Author" was first published in France in 1968, the year Warhol was shot. See "The Death of the Author" (1968), in IMAGE, MUSIC, TEXT, ed. and trans. Stephen Heath (New York: Hill & Wang, 1977), 142–148.
6—Kynaston McShine, introduction to ANDY WARHOL: A RETROSPECTIVE, exh. cat., ed. Kynaston McShine (New York: Museum of Modern Art, 1989), 17.
7—Gene Swenson, "What Is Pop Art? Answers from Eight Painters," ART NEWS 62 (November 1963): 60.

Coming of age
in celluloid-land

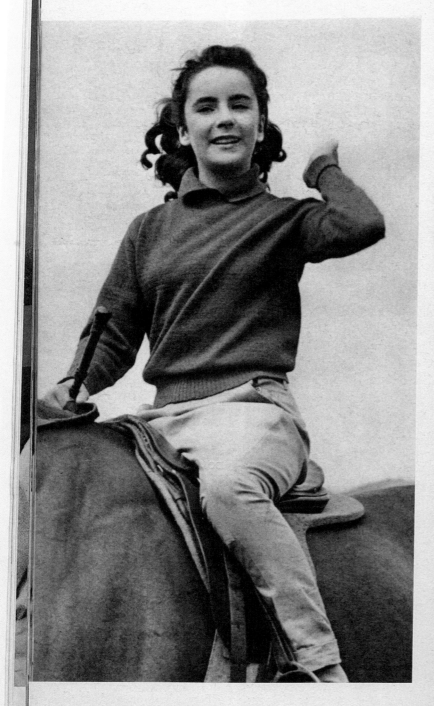

GIRL INTO WHAT? From the joyous juvenile (*above*) riding a horse in *National Velvet* to the *femme fatale* of *Cleopatra* (*right*) Liz Taylor has accomplished a transition which to most adult Americans seems unconscionably swift. Could that child be 30 years old? Or on the other hand, could that woman be 12?

It is impossible to deny that Elizabeth Taylor has become a movie actress of great skill; sometimes she exhibits flashes of genius on the grandest scale. But what next for the princess? As Shakespeare said of a surfeit of honey, "a little more than a little is by much too much." Upward lies the moon; inward lies the heart; and onward lies a world not made of celluloid.

40

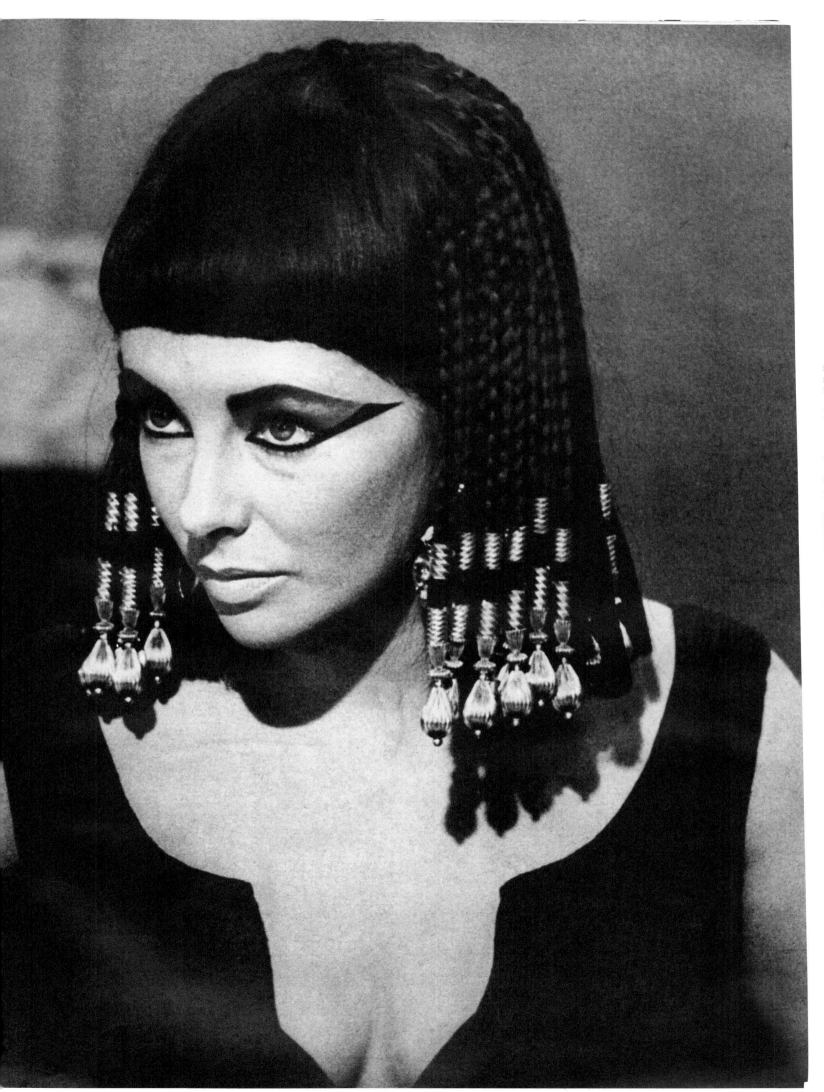

FIG. 2 — Spread from the April 13, 1962, issue of LIFE magazine with photographs of Elizabeth Taylor that served as source images for NATIONAL VELVET (pl. 29) and the Liz as Cleopatra paintings (pls. 30–32)

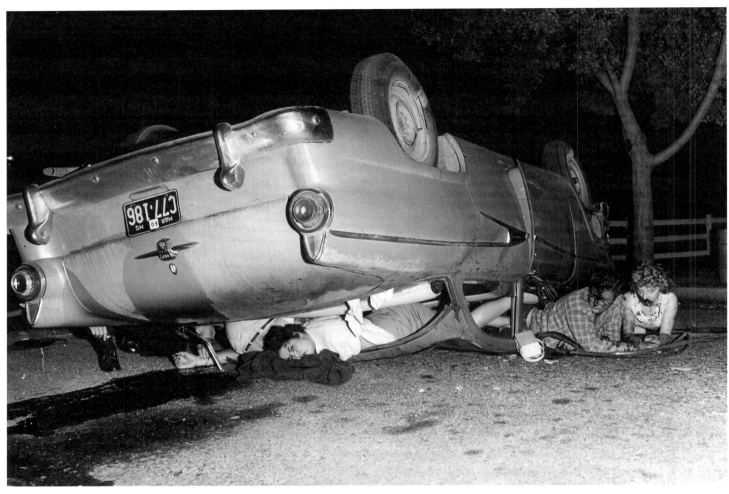

FIG. 3—United Press International (UPI) photograph that served as the source image for the Five Deaths paintings (pls. 14–18, 20); Archives of The Andy Warhol Museum, Pittsburgh

with one panel in color and another in black-and-white. Here sex and death come into intimate proximity as the fragmented image of the actress's saturated lips metonymically becomes a kind of painterly relic.[8]

Much critical ink has been spilled over both the artistic and the cultural implications of these works. For our purposes, Warhol's repetition of Monroe's image was as much an homage to a recently departed American icon as it was a reflection of the rapaciousness of both Hollywood and the media in creating, consuming, and discarding stars. What is clear from Warhol's work is that his early paintings of celebrities were often just as much "disasters" as the works that were officially given that name. Monroe was herself a disaster, a "bad star" if you will, having flamed out like a supernova after a phenomenal rise to stardom. In her post-Warhol afterlife, she has taken on the characteristics of one of the living dead, reincarnated in the pop cultural imagination by a succession of imitators, most notably in the 1980s by Madonna.

At first glance Warhol's paintings of Elizabeth Taylor would not seem to share the sepulchral qualities of his images of Marilyn. As a number of art historians, including Thomas Crow, have noted, however, Taylor was at the time going through her own serious and very public health crises, at one point causing a delay in the completion of Joseph L. Mankiewicz's 1963 film extravaganza *Cleopatra*, in which she played the leading role.[9] Warhol himself related the Liz paintings to the theme of death quite explicitly: "I started those [pictures of Elizabeth Taylor] a long time ago, when she was so sick and everybody said she was going to die."[10] Taylor's life was also, like that of Monroe, fodder for the scandal sheets, as she was notorious for her numerous tempestuous marriages (and subsequent divorces). Paintings such as *Blue Liz as Cleopatra* (1962; pl. 31), the series of Silver Liz pictures executed in the summer of 1963 (pl. 33), and the unique work *National Velvet* (1963; pl. 29) would each contribute to the mythological aura surrounding Taylor while at the same time providing something of a

8—In the case of the Marilyns, violence haunted even the actual paintings. Victor Bockris recounts an event from 1964: "Around this time one of the mole people's witches, Dorothy Podber, came to the Factory with her dog, Carmen Miranda, and asked Andy if she could shoot his Marilyn paintings. When he said he didn't mind, Dorothy put on a pair of white gloves and pulled a small German pistol out of her pocket, aimed at a stack of Marilyn Monroe paintings, and shot through the middle of the forehead. After she left, Andy went over to Ondine and said, 'Your friend just blew a hole through . . . ' Ondine said, 'But you just said she could'" (Victor Bockris, WARHOL: THE BIOGRAPHY [London: Da Capo Press, 1989], 200–201). These single-image paintings of Monroe were then retitled by Warhol SHOT RED MARILYN, SHOT LIGHT BLUE MARILYN, SHOT ORANGE MARILYN, and SHOT SAGE BLUE MARILYN. He sold them all.

critical (or at least structural) framing of the mechanism through which this star was born. It is important to note that any assumed distance that these works generated from their subjects at the time was tempered by the fact that Warhol was drawing on completely contemporary images and tastes. The same media frenzy that fed the publicity machine also fed his paintings, as the source images for both *National Velvet* and the Liz as Cleopatra paintings were derived from the April 13, 1962, issue of *Life* magazine, which devoted its covers and a large spread to Taylor under the banner headlines "Blazing New Page in the Legend of Liz" and "Coming of Age in Celluloid-land" (fig. 2).

Celluloid-land was of course the setting for numerous other stories illustrating the pitfalls of fame, including the life and career of Elvis Presley. In his series of silver Elvis paintings executed in 1963 for an exhibition at the Ferus Gallery in Los Angeles that fall (pls. 49–51, fig. 14), Warhol appropriated a publicity image of Elvis as a cowboy sporting a drawn pistol. The image was taken from the film *Flaming Star*, a B-grade western directed by Don Siegel that was released in 1960. It would be hard to find a film whose title contains a more fitting allusion to the connection of stardom and disaster embodied in the idea of the supernova. We would have to wait well into the 1970s for the true tragedy of Elvis Presley to play itself out as the singer went from rock and roll superstar to film star to Las Vegas camp icon before ignominiously succumbing to his own demons as he died in the bathroom of his Graceland estate from some deadly combination of glazed donut–induced coronary disease and an excess of prescription medications.

Pop star flameouts were hardly the only catastrophes that fascinated Warhol. In June 1962 the critic Henry Geldzahler suggested to Warhol that he take up the theme of death in his work, reportedly handing him a copy of the *Daily News* with the headline "129 Die in Jet," which became the basis for one of the artist's last hand-painted works. Warhol would then go on to create his monumental and at times gruesome monochromatic repetitions of newspaper images of other "disasters" gleaned from the news, such as his iconic *Green Disaster #2* (1963; pl. 12), *Orange Car Crash* (1963; pl. 13), and the black-and-white *Saturday Disaster* (1963–1964; pl. 24). In each of these works the artist appropriated, enlarged, and repetitively silk-screened onto his canvases news photographs of terrible accidents derived from photojournalistic sources. These anonymous, frequent, and all too ordinary disasters offer up a collective portrait of a culture defined by what the critic Peter Schjeldahl, writing about these paintings, once referred to as "images of plebeian catastrophe."[11]

The fame reflected in these pictures—like that embodied in the artist's Most Wanted Men series of 1964 (pls. 35–38), derived from the mug shots of the top criminals on the FBI's most-wanted list—is paradoxically one that is drenched in anonymity. For the criminals it is more a question of infamy than fame as such, while the car wrecks are the chance product of bad luck and the inopportune mixture of speed, metal, and physics. Like those that

killed such glamorous or at least culturally significant figures as James Dean or Jackson Pollock, whose deaths subsequently took on a romantic aura, such accidents gave the ordinary person a chance to be famous or at least play a somewhat notable part in a violent spectacle. The drawback to this kind of fame is its fleeting character and the fact that one isn't around to enjoy it. As Warhol once said about death, "I don't believe in it, because you're not around to know that it's happened."[12]

Taking on the quality of the memento mori prevalent in Renaissance painting, Warhol's car crashes were joined by his series of electric chair paintings and his Tunafish Disasters. In a wide range of works, including *Lavender Disaster* (1963; pl. 41), he repeated a single solemn image of an empty electric chair in an execution chamber. The sobriety of this found image representing the definitive marker of the failure of the social contract stands in sharp contrast to its incongruous repetition fifteen times on a bright purple canvas. Here, as in so many of these works, Warhol transformed this mute photograph through its multiplication and its translation into garish colors. Unlike his other works from this period, the electric chairs represent disasters in potentia—events waiting to happen—and are a sign of the banality of death in a culture that defines itself through its self-portrayal in the mass media.

Tragedy comes in many forms, however, and sometimes it is the sanitized and prepackaged world of consumer products that turns on us to provoke another kind of calamity. Warhol's series of Tunafish Disasters of 1963 (pl. 28)—which take their source material from the April 1, 1963, issue of *Newsweek*—focus on the deaths of a number of people from cans of tainted tuna fish. Here the glossy, prepackaged, and hermetically sealed world of everyday mass-produced commodities that forms Pop Art's field of dreams comes back to haunt us as consumption leads to unexpected death.

Completing Warhol's holy trinity of female "stars" is the lone, tragic figure of Jacqueline Kennedy. In works such as *Sixteen Jackies* (1964; pl. 52), we close the circle, coming back to the interplay of celebrity and tragedy that defined Warhol's images of Marilyn and Liz. These female icons of popular culture occupied dichotomous poles of American femininity, with one embodying political dynastic nobility while the two film stars were enshrined as the mythological deities of Hollywood sex appeal and glamour. As with Marilyn and Liz, Warhol's near obsession with press images of Jackie just after the assassination of her husband, President John F. Kennedy, in 1963 resulted in an enormous body of paintings based on these photographs. Moving from single panels to multiple images, Warhol would deploy and juxtapose images of the happy pre-assassination Jackie with those of the mourning post-assassination Jackie. As television broadcasts would endlessly show footage from the 8mm film taken of the Kennedy assassination by Abraham Zapruder, Jackie herself would become the unwitting star of her very own film.

In these works Warhol enshrined Jackie as a grieving widow while at the same time marking the end of the period of hope-filled, youthful exuberance that would come to define the "Camelot" image of the Kennedy presidency. When taken together

9—In Crow's opinion it was not just their proximity to death that linked Monroe and Taylor in the popular imagination: "As unchallenged Hollywood divas with larger-than-life personal myths, Monroe and Taylor were nearly equal. Each maintained her respective position by a kind of negative symmetry with the other, by representing what the other was not." See Thomas Crow, "Saturday Disasters: Trace and Reference in Early Warhol," ART IN AMERICA 75 (May 1987): 134.

10—Swenson, "What Is Pop Art?" 60.

11—Peter Schjeldahl, "Warhol and Class Content," ART IN AMERICA 68 (May 1980): 118.

12—Warhol, PHILOSOPHY OF ANDY WARHOL, 123.

Warhol's paintings from this period start to take on the character of history paintings chronicling the end of what Henry Luce once called "the American century."

with his perhaps ironically titled Race Riot paintings of 1963 and 1964 (pls. 45–48), which derive their source material from a *Life* magazine photograph of police dogs attacking civil rights protestors in Birmingham, Alabama (fig. 6), Warhol's paintings from this period start to take on the character of history paintings chronicling the end of what Henry Luce once called "the American century."

What is now a commonplace and somewhat clichéd interpretation of Warhol's paintings suggests that they were at best disengaged from the world and at worst cynically exploitative of his subjects. Robert Hughes was an advocate of this position, castigating Warhol in the *New York Review of Books* in 1982 as being an artist concerned more with his own fame than with making significant works of art.[13] A more nuanced critique was offered in 1989 by Thierry de Duve in his essay "Andy Warhol; or, The Machine Perfected," published in *October*, the über-theoretical bible of 1980s critical discourse. De Duve begins by asserting: "To desire fame — not the glory of the hero but the glamour of the star — with the intensity and awareness Warhol did, is to desire to be nothing, nothing of the human, the interior, the profound. It is to want to be nothing but image, surface, a bit of light on a screen, a mirror for the fantasies and a magnet for the desires of others — a thing of absolute narcissism." De Duve's line of argument leads him to a conclusion vastly different from that reached by Hughes, however. Far from suggesting a pervasive cynicism in the early silkscreen works, de Duve implies that Warhol's attempts to achieve a machinelike demeanor gave these works their greatest attribute: the ability to testify. As he points out, "to testify is neither to promise nor simply to expose; it is to attest to reality as it is, in the past or present." This capacity to bear witness to the state of the world in which we live enabled Warhol to "[incarnate] the American dream to nightmare pitch" as he "made visible its terrible death drive."[14]

While acknowledging Warhol's preoccupation with fame, de Duve ultimately sees him as a documentarian of a world at risk, and there is to my mind something extraordinarily human and sympathetic about Warhol's images of stars, deaths, and disasters. Writ large on the cultural canvas, these paintings speak to our collective obsession with our own mortality, offering an unvarnished view of American culture. As Thomas Crow wrote in relation to the Disaster paintings in 1987, "What this body of paintings adds up to is a kind of *peinture noire* . . . a stark, disabused, pessimistic vision of American life, produced from the knowing rearrangement of pulp materials by an artist who did not opt for the easier paths of irony or condescension."[15] Others have even argued that there is a hopefulness inherent in Warhol's work, most notably the painter Robert Longo in 1989: "Shortly after [Warhol's] death, I saw a two paneled, orange car crash from 1963 in a small group show at Castelli's — it was so fresh, simple, and sublime, as if no one had actually made it and it had always existed. In this age of the shrug, when our civilization could well die of indifference from within, Warhol took that sense of decay and numbness and gave it a new passion, a new picture, a new hope."[16] Nearly twenty years after Longo made this statement, we increasingly can no longer afford to live in the "age of the shrug." Looking back at this body of Warhol's work from today's perspective, it seems clear to me that there is indeed something hopeful about his framing of the perverse concatenation of celebrity and disaster in American culture.

18

13 — See Robert Hughes, "The Rise of Andy Warhol," NEW YORK REVIEW OF BOOKS, February 18, 1982; reprinted in Brian Wallis and Marcia Tucker, eds., ART AFTER MODERNISM: RETHINKING REPRESENTATION (New York: New Museum of Contemporary Art, 1984), 45–57.
14 — Thierry de Duve, "Andy Warhol; or, The Machine Perfected," OCTOBER, no. 48 (Spring 1989): 4, 6, 13.
15 — Crow, "Saturday Disasters," 136.
16 — Robert Longo, in "A Collective Portrait of Andy Warhol," in McShine, ed., ANDY WARHOL, 448.

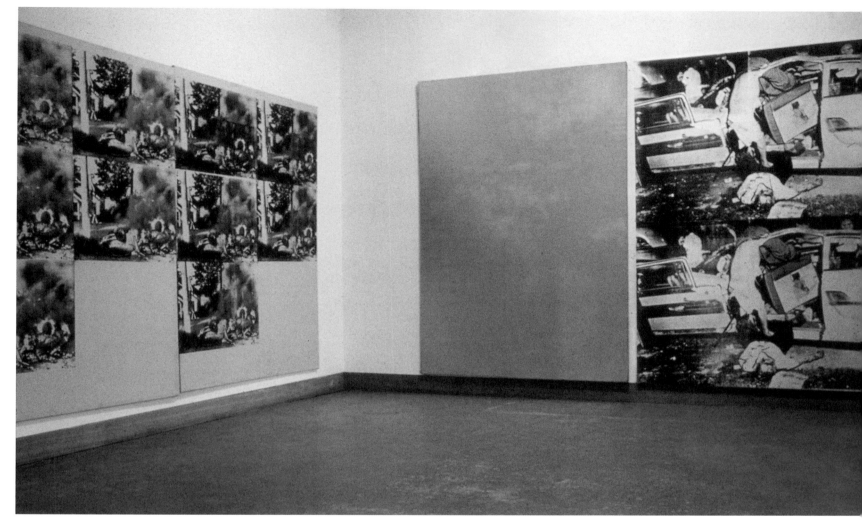

FIG. 4 — Installation view, ANDY WARHOL, Institute of Contemporary Art, University of Pennsylvania, Philadelphia, October – November 1965

In *Regarding the Pain of Others*, Sontag concludes her reconsideration of the question of the numbing effect of images of death and disaster by suggesting the possibility of an ethical function for the repeated viewing of photographs of horrific events: "Let the atrocious images haunt us. Even if they are only tokens, and cannot possibly encompass most of the reality to which they refer, they still perform a vital function." She goes on to offer a defense of the value of these images even in an age of apathy. "That we are not totally transformed, that we can turn away, turn the page, switch the channel, does not impugn the ethical value of an assault by images."[17] I would argue that this ethical dimension can be found in the work of Andy Warhol as well.

It has been said that history stutters. In 2005 we are inextricably programmed by the media world that was coming into its own in the 1960s. Some forty years ago, Warhol offered us a premonition and a dispassionate diagnosis of a culture that cannibalistically feeds on its own images of death and disaster. He held up a mirror to a society in which the Zapruder film, with its endless repetition of the Kennedy assassination, would come to emblematize a media environment that has become part of our collective DNA. Indeed, we now live in a world that is defined by a Zapruder film of the mind. In the age of VH1's *Behind the Music* and other examples of the media's fixation on "rags to riches to rags" dramas, Warhol's Disasters — even if they are merely "tokens," as Sontag would have it, of authentic experiences and emotions — provide a sobering historical counterpoint and critical antidote to our voracious consumption of the uninterrupted flow of information, giving us pause before we televisually eat our own dead.

17 — Sontag, REGARDING THE PAIN OF OTHERS, 115, 116.

Francesco Bonami

PAINTINGSLAUGHTER

HOW ANDY WARHOL DID NOT MURDER PAINTING BUT MASTERMINDED THE KILLING OF CONTENT

IF EMPATHY DEFINES WHAT IT MEANS TO BE HUMAN, THEN ONE DAY ANDROIDS WILL BE GIVEN THIS ABILITY. IF TO BE HUMAN MEANS TO HAVE A SENSE OF THE SACRED, THEN THEY WILL BELIEVE IN GOD, WILL SENSE HIS PRESENCE IN THEIR SOULS, AND WITH ALL THEIR CIRCUITS FIRING WILL SING HIS PRAISES. THEY WILL HAVE FEELINGS AND DOUBTS, THEY WILL KNOW ANGUISH AND FEAR. THEY WILL EXPRESS THEIR FEARS IN BOOKS THAT THEY WILL WRITE. AND WHO WILL BE ABLE TO SAY WHETHER THEIR EMPATHY IS REAL, WHETHER THEIR PIETY, THEIR FEELINGS, THEIR DOUBTS, AND THEIR FEARS ARE GENUINE OR MERELY CONVINCING SIMULATIONS? *Emmanuel Carrère*[1]

Avoiding any revision of art history, can we ask ourselves, "Was Andy Warhol an android?" Androids are those "people" described by Philip K. Dick in his sci-fi novel *Do Androids Dream of Electric Sheep?* made world famous by Ridley Scott's movie adaptation, *Blade Runner*. Looking at Warhol's Death and Disaster paintings, it is logical to question his empathy for the subjects he selected for his canvases. Warhol never pretended to be a social critic; in fact, he was proud to be a socialite. His doubts, feelings, fears,

and anguish were not about the society he was living in but about his place in society.

We could go along with Warhol's attitude and still enjoy his amazing work, his capacity to extract from the drama of the world the best possible images, transforming them into icons. We could still go along with the surface and the superficiality and stick with his role in the art world and art history. We could go along with this simulation and his simulation, but . . . Yes, there is a but, even

1—Emmanuel Carrère, I AM ALIVE AND YOU ARE DEAD: A JOURNEY INTO THE MIND OF PHILIP K. DICK, trans. Timothy Bent (New York: Metropolitan Books, Henry Holt, 2004), 138.

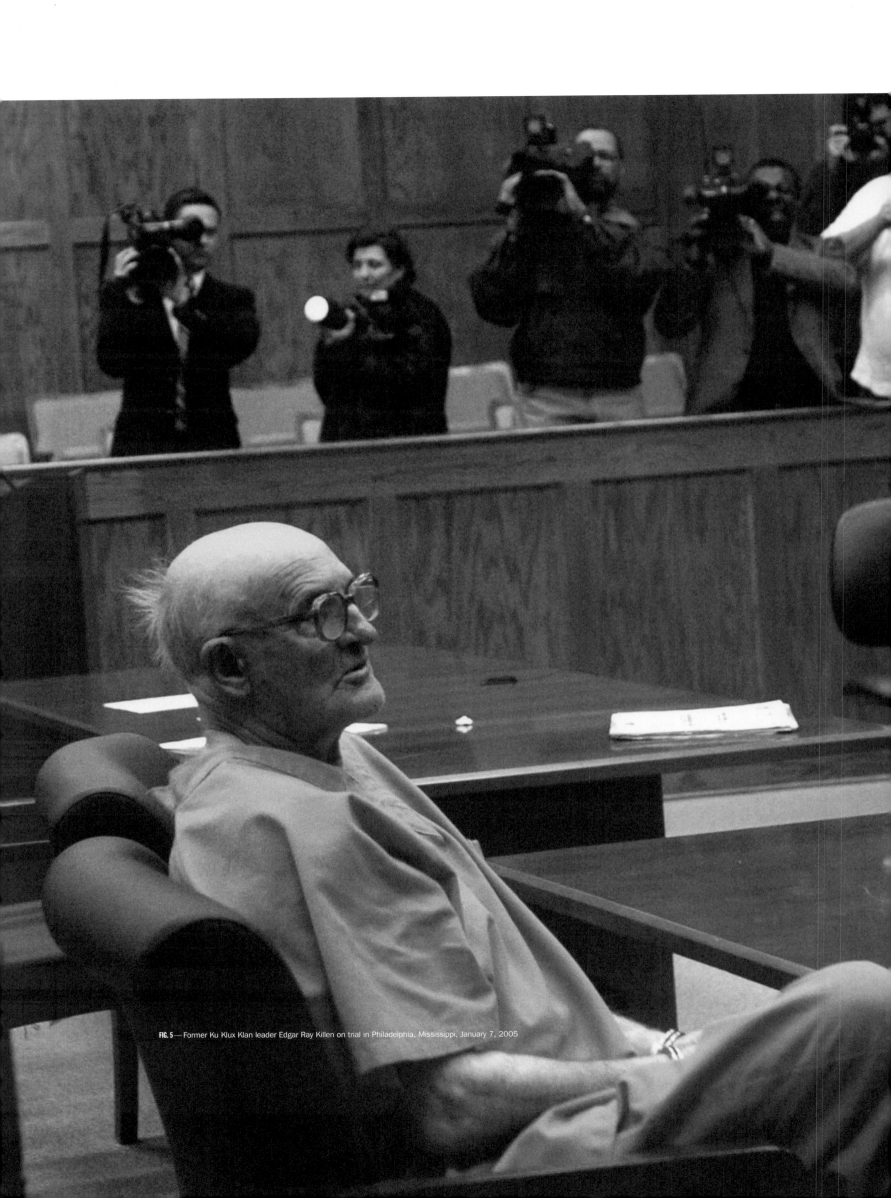

FIG. 5—Former Ku Klux Klan leader Edgar Ray Killen on trial in Philadelphia, Mississippi, January 7, 2005

for the supernova Andy Warhol, because history has changed and forced us to look at these works through the lens of our time. In the last few years a few forgotten names have been brought back from the past: names like Edgar Ray Killen (fig. 5), the man who instigated the murder of three civil rights workers in Mississippi in 1964; Byron De La Beckwith, who killed Medgar Evers in Jackson, Mississippi, in 1963; and Thomas Blanton Jr., who participated in the bombing of a church in Birmingham, Alabama, in which four young girls were killed. For more than forty years we believed in a simulation of justice, until these people were dragged out from their darkness in a series of atonement trials in which they were finally convicted for their crimes. It was not about truth and reconciliation, because nobody was able to say the truth or to be reconciled with that past, but it was about the final closure of an open wound within American society.

In the years of the civil rights struggles, Andy Warhol was pillaging the chronicles to build one of his most important bodies of work. Did he care about what was going on in his country? Did he care about the outrageous reality that was unraveling under the feet of American democracy? My guess is that he did not, as many other New Yorkers did not, committed to the swinging rhythm of the roaring sixties. He did not look the other way — in fact, he looked very carefully at what was happening — but he was able to neutralize and purify of moral content anything he could see as possible subject matter for his paintings. Jacqueline Kennedy's sorrow at JFK's funeral and the violence toward civil rights demonstrators in Birmingham had for Warhol the same aesthetic weight and social value. Does this attitude make him guilty of something? In theory not, and I don't know of anybody who has raised this issue, has questioned whether we can still accept Warhol's genius without questioning his moral and political detachment from the dramatic events that were reshaping a society in which he, as an artist, was living and prospering.

I know that this sounds moralizing, but what we would have done if an artist working in the 1980s had exploited the imagery of the AIDS crisis simply for its aesthetic value, voided of its political and social implications? Warhol was spared the nightmare of political correctness, but that is not a justification for not taking a second look at a body of work that used issues without addressing them. People were killed, lynched, burned, and discriminated against, and Andy was painting, Andy was dreaming of electric sheep, Andy was composing history using its music and discarding its screams. He was doing all of this almost in real time. On May 17, 1963, three photographs by Charles Moore of civil rights demonstrators being attacked by police dogs in Birmingham, Alabama, were reproduced as a double-page spread in *Life* magazine. By the end of June 1963 *Pink Race Riot* (pl. 46), *Mustard Race Riot*, *Race Riot* (pl. 45), and other variations were coming out of Warhol's studio.[2]

There is a disturbing synchronicity between the events that were unfolding in the southern United States and Warhol's artistic production. His hand seemed to dig into reality while it was still

2 — From May 2 to May 7, 1963, Martin Luther King organized hundreds of Birmingham high school students to peacefully protest segregation, hoping that images of their persecution would elicit national and international condemnation of the inhumane conditions in Birmingham. When the peaceful demonstrators were fire-hosed, attacked by police dogs, and beaten by police, many of Birmingham's black residents began to defend the protestors by attacking the police. Warhol's title, RACE RIOT, suggests that he may not have perceived the seventeen-year-old in Moore's photos as a victim rather than an aggressor. Nevertheless this image and others illustrated the growing violence of the civil rights struggle, which was widely broadcast on television.

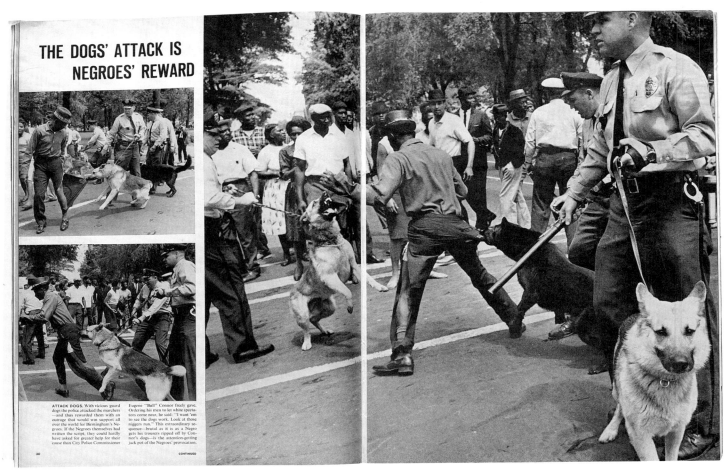

THE DOGS' ATTACK IS
NEGROES' REWARD

FIG. 6 — Spread from the May 17, 1963, issue of LIFE magazine with photographs that served as source images for the Race Riot paintings (pls. 45–48)

hot but with no fear of being burned. He was extremely alert to the images pouring out from the news but totally detached from their implications. He was no Théodore Géricault. The latter made clear his sorrow and indignation over the tragedy of the *Medusa*, in which a group of sailors were abandoned to their destiny in the middle of the ocean following a shipwreck, an event that created a scandal in the French government. Géricault painted his masterpiece, *The Raft of the Medusa* (1818–1819), without sparing the viewer any of the emotional implications of the event, and his work provoked the ire of the authorities. Warhol did the opposite, offering the viewer simply the beauty of horror, a very dangerous concept often applied to images appearing from the hell of the Holocaust (for example, photographs of mountains of shoes or of bodies in mass graves). The seduction of repeated images, their balanced composition, the archaic stillness of the German shepherd in the foreground, act in conjunction to erase the humiliating vision of another dog biting the back of a black demonstrator, transforming the tragic document into a sort of slapstick.

I don't think that Warhol was at all aware of the effects of his technique and creative talent on the material he was using. He was dramatically and desperately sincere in his renunciation of any political or social critique. He didn't like what was happening, but he could not help liking what what was happening revealed. Images of death, disaster, and violence make news and mesmerize people, and that is what Warhol was interested in. Average people like fame and fame by default, that is, death. Andy Warhol was an average person and was proud of it. Until trouble reaches them, average people don't like to be mixed up with it. Eventually trouble caught up with Warhol, through the delusional rage of Valerie Solanas, head of the one-person organization SCUM, but it was too late to transform him into an activist.[3]

The reaction to Warhol's first show in Paris in 1964 at Ileana Sonnabend's gallery — which included *Pink Race Riot*, together with other Death and Disaster paintings — was mixed. The American poet John Ashbery, who served as the Paris-based art critic for the *New York Herald Tribune*, wrote that the work

24

3 — Solanas, who had appeared in Warhol's films I, A MAN and BIKE BOY, wrote a violently antimale screed called the SCUM MANIFESTO and the play UP YOUR ASS. When Warhol failed to produce or return Solanas's script, she became convinced that he was planning to steal her ideas, and on June 3, 1968, she shot him at the Factory, causing permanent injuries that forced him to wear a corset for the rest of his life and ultimately contributed to his death in 1987. When asked what her motives were, she claimed that Warhol had "too much control" over her life, saying: "I just wanted him to pay attention to me. Talking to him was like talking to a chair" (quoted in Bob Colacello, HOLY TERROR: ANDY WARHOL CLOSE UP [New York: Cooper Square Press, 2000], 32).

"marks a turning point in the Pop movement." He continued: "From the beginning there has been a polemical element in Pop art, but it is one thing to poke fun at supermarkets and TV commercials, and another to use art as a means of confronting us with the raw terror of so much that happens today. . . . With Warhol . . . his latest work is unmistakably polemical, or as the French say, engagé. And he brings all his tremendous talent for meaningful decoration to the task of putting his message across. His show shakes you up."[4]

The French critic Gérald Gassiot-Talabot, however, writing in *Art International*, questioned the paintings' validity as art, focusing on the technique rather than the content: "Warhol and his peers demand that we radically revisit the criteria for aesthetic appreciation—insofar as these artists assert, with often delicious cynicism, a conceptual and technical laziness whereby they prefer the methods of automatic reproduction to the vagaries and tiresome aspects of traditional craft. Unfortunately, so long as the definition of art presupposes personal, voluntary intervention by the painter, Warhol will reside in that indistinct fringe of creative depersonalization where the refuse collectors of Nouveau Réalisme . . . have erected a whole swath of current artistic practice, while possessing a human note that Pop does not."[5]

The French and other Europeans did not seem to interpret this body of work as condemning the United States as a violent, racist society. Instead they seemed to accept Warhol's paintings as another manifestation of what they felt was the biggest threat to their monopoly on contemporary culture, engineered by the crassly commercial New York art world. Ashbery's response notwithstanding, I don't think that political awareness was yet dominating the discussion in any part of the art world. A few more years needed to pass in order to see visual art become an outlet for the counterculture and radical politics. The civil rights struggle was a marginal and faraway event for the European intelligentsia.

As Gassiot-Talabot's comments suggest, the outrage in the art world at the time was not about politics, but about the disruption of the idea of painting. The silkscreen technique was transforming the canvas from a surface into a screen. Warhol—along with Robert Rauschenberg, who in the summer of 1964 became the first American to win the grand prize at the Venice Biennale—was jeopardizing the future existence of those painters who were still discussing color and form rather than content. The civil rights movement, compared with the crumbling of colonial empires in places such as Algeria and Vietnam, was probably for Europe simply a footnote from a childish society with a few growing pains. Andy Warhol's art confirmed this idea of a childish society. The revolutionary aspect was confined to its aesthetics, not its ethics.

Today it is not easy to accept the kind of flirtation with the repetitive patterns of tragedy that Warhol transformed into some of his signature pieces. At the same time the detached commentary of the Race Riot paintings and similar works placed Warhol in the very limited realm of great artists who have portrayed the events of their day—a realm populated by names like Velásquez,

The detached commentary of the Race Riot paintings and similar works placed Warhol in the very limited realm of great artists who have portrayed the events of their day.

David, Géricault, Delacroix, Goya, Picasso, and, I'm afraid, very few others. It is perhaps a kind of natural aloofness, irresponsibility, or superficiality that allows a great artist to represent history as a work of art and not simply as a cold document. Warhol walked a tightrope over the gorge of frigid documentation, but his selection of background colors and balancing of negative space saved him from falling. The background color became a kind of beautiful screen, mitigating the harshness of the subject matter, trans-

4—John Ashbery, "Pop Artist's Horror Pictures Silence Snickers," NEW YORK HERALD TRIBUNE, January 15, 1964.
5—Gérald Gassiot-Talabot, "Lettre de Paris," ART INTERNATIONAL 8 (March 20, 1964): 78–80; translation by Michael Gilson.

All of Richter's images are trapped in a limbo between feelings and reality, while Warhol's bulimic capacity to swallow the moment and spit it out as another image helped the Deaths and Disasters to escape both feelings and reality and transform themselves into pagan icons, devoid of any moral weight.

forming the images into dreamlike visions rather than documents. Whether motivated by cynicism or some mysterious philosophical bent, Warhol grasped the possibility that history and its tragedy are nothing but wallpaper for our identities and souls.

In saying this, I may be granting Warhol more credit than he deserves and a depth that he never dared to dip into. Among the painters who have succeeded in creating great works addressing momentous events, I deliberately left out Gerhard Richter, who perhaps produced the last great cycle of historical canvases with October 18, 1977 (1988; fig. 7), which commemorates the deaths of members of the Baader-Meinhof group, militant political activists who were part of the Red Army Faction. Whereas Warhol was frigid toward his subjects, Richter has the remoteness of depression. His methodical way of painting and the murkiness of the images, as well as his selection of subjects, suggest the slowness of memory and forgetfulness. In fact, he began painting the October 18, 1977 cycle eleven years after the event, when the facts were on the verge of fading from the collective memory. This gap of time gave him a credibility that spared him some of the accusations of exploiting a national and human tragedy. [6]

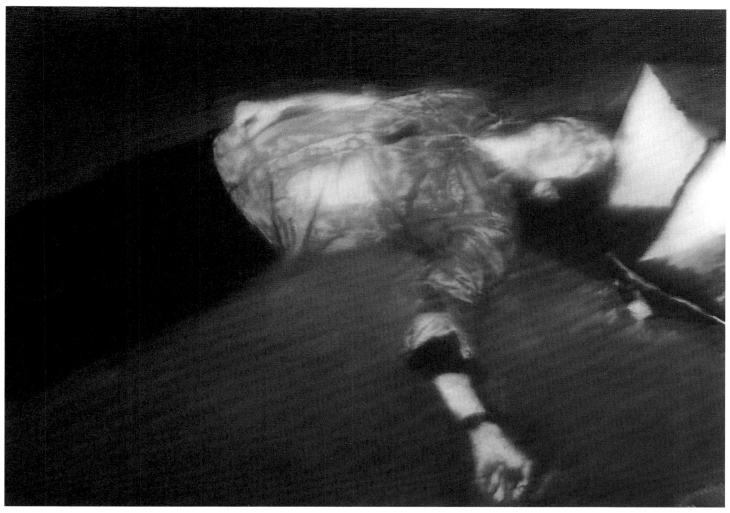

FIG. 7—Gerhard Richter MAN SHOT DOWN 1 (ERSCHOSSENER 1) 1988 oil on canvas 39 ½ x 55 ¼ in. (100.5 x 140.5 cm) Collection The Museum of Modern Art, New York. The Sidney and Harriet Janis Collection, gift of Philip Johnson, and acquired through the Lillie P. Bliss Bequest (all by exchange); Enid A. Haupt Fund; Nina and Gordon Bunshaft Bequest Fund; and gift of Emily Rauh Pulitzer

Richter never painted images of the Holocaust, carefully avoiding any confrontation with his latent guilt as a German individual. But his method, like memory, does not allow for any atonement or closure. All of Richter's images are trapped in a limbo between feelings and reality, while Warhol's bulimic capacity to swallow the moment and spit it out as another image helped the Deaths and Disasters to escape both feelings and reality and transform themselves into pagan icons, devoid of any moral weight.

In Philip K. Dick's book, the main character, Rick Deckard, belongs to a quasireligious cult that uses a ritual instrument called an empathy box. In Dick's future, people need this because they have lost the normal capacity to feel emotion. This small appliance allows its users to identify with another person by making them imagine that they are sharing the suffering of Wilbur Mercer, a legendary figure on whom the cult is centered. They hallucinate images of Mercer climbing a mountain, experiencing fatigue, rest, sadness, joy, and so on. We find out at the end of the novel that this instrument is based on a fraud. Mercer is exposed by the talk show host Buster Friendly as a pathetic Hollywood actor fallen on hard times. Mercer appears to confirm the scam, yet that doesn't change a thing, he says, "Because you are still here and I'm still here." Warhol could have owned an empathy box; he could have been, and probably was, a sort of a fraud. Yet that doesn't change a thing. Today we could not accept Warhol's superficial, apolitical positions, but — yes, there is another *but* — we are still here, and luckily so are his paintings.

6—Nevertheless, the political left accused the painter of exploiting a tragedy that shaped the awareness of a generation, while conservatives accused him of glorifying individuals who were nothing more than murderers. Peter Wollen defends Richter against charges of both exploitation and hagiography in "Leave-Taking," LONDON REVIEW OF BOOKS 23 (April 5, 2001), http://www.lrb.co.uk/v23/n07/woll01_.html. See also Robert Storr, GERHARD RICHTER: OCTOBER 18, 1977 (New York: Museum of Modern Art, 2000).

FIG. 8 — Andy Warhol SHADOWS 1978/1979 silkscreen ink and synthetic polymer paint on canvas 80 x 192 in. (203.2 x 488 cm) private collection

David Moos

ANDY WARHOL, PAINTER

IF YOU WANT TO KNOW ALL ABOUT ANDY WARHOL, JUST LOOK AT THE SURFACE OF MY PAINTINGS AND FILMS AND ME, AND THERE I AM. THERE'S NOTHING BEHIND IT. *Andy Warhol*

Two years after Warhol's death, Julian Schnabel wrote an essay about the Pop icon. "Andy's greatest contribution is in the traditional area called painting," Schnabel asserted, transferring emphasis away from the glib media persona and toward the canvases themselves. Focusing on one of Warhol's lesser-known series of works, the Shadow Paintings, which were produced in 1978, Schnabel offered eloquent insight that could perhaps come only from another painter: "In Andy's case, the way he used the screen as an additional brush is the printed emblem of his behavior, the symbol of a philosophy of a distance whose radicality lies in its straightforwardness. His decision to select and to act without interpretation, without explanation, was the utter denial of the sentimental. This gesture remains as the irreducible image of Andy's painting; the irreducible clarity of distance."[1] Looking beyond the images that he chose, Schnabel understood that Warhol's method of painting — the smudging and breaking up of images and the clogs and defacements that constitute what he calls "the new distanced picture" — was essential to the work. Considering a very large Shadow Painting that is devoid of any recognizable imagery (fig. 8), Schnabel came to realize that these canvases were Warhol's arch sign that his work was about painting, about the making and meaning of painting.

To foreground such an insight seems paradoxical, for Warhol's imagery is among the best known and most recognizable produced by any painter in the twentieth century. Indeed his paintings deploying the faces of Marilyn Monroe, Elizabeth Taylor, Elvis Presley, and Jacqueline Kennedy have beguiled successive generations of viewers and critics, who have engaged their immediate content, often minimizing Warhol's painterly tropes.[2] Moreover, in the seminal work from 1962 to 1964 that presents imagery of alluring movie stars and repulsive disaster scenes, which is the focus of the current exhibition, Warhol made unique formal decisions. His use of color, repetition of motifs, relative canvas size, single- versus double-panel compositions, and calculated selection of subject matter provide his painting with its pictorial power. By utilizing the silkscreen technique for primarily figurative purposes, he ingeniously brought to resolution one of the central problematics in modern painting — the relationship between figure and ground — dissolving and even inverting the distinction.

In such seemingly traditional painting terms, the radicality of Warhol's painting can be appraised. Although he almost eliminated texture from the surface of his paintings and suppressed notions of the brush stroke, presenting wondrously smooth planes on which images reside like apparitions, the works are rooted in conventional constructs. The success of Warhol's project — now central to the imagination of contemporary art — can be traced to how his early silkscreen work responds to and recodes topics in modern painting, from Cubism through to Abstract Expressionism and American painting of the 1960s. Indeed, Warhol's development was remarkably strategic from late 1961 through 1964, when his project as *painter* reached full and mature formulation. In these crucial years he rigorously deconstructed tenets of modern painting, using subject matter to critique and understand

29

1—Julian Schnabel, introduction to ANDY WARHOL: SHADOW PAINTINGS, exh. cat. (New York: Gagosian Gallery, 1989), 5, 6.
2—As Benjamin H. D. Buchloh has noted, "one could say that most of the Warhol (and Pop) literature has merely reiterated the clichés of iconographic reading since the mid-sixties" ("Andy Warhol's One-Dimensional Art: 1956–1966," in ANDY WARHOL: A RETROSPECTIVE, exh. cat., ed. Kynaston McShine [New York: Museum of Modern Art, 1989], 51).

Unlike the action painter's method—Rosenberg characterized the process of painting as "putting forms into motion" and invoked the "painter's muscles" to conjure rapid movement—Warhol's method is rooted in the much slower temporality of collage. The paintings that led up to his use of silkscreen describe his preoccupation with forcing the procedures of collage onto the smooth surface of canvas.

tradition. Indeed, the logic underlying his choice of subject matter and its articulation can be read as a direct response to strategies crucial to earlier twentieth-century art movements.

Among Warhol's first canvases to utilize the silkscreen technique—which, as Schnabel correctly adduced, became Warhol's emblematic "additional brush"—is *Troy Diptych* (1962; pl. 7). Presenting regimented rows of images of actor Troy Donahue's face, the composition is split into two conjoined panels. The left canvas contains images printed in red, yellow, blue, and black,

while the large right canvas displays visages printed simply in black. The great variance in the clarity of the image, with some of the faces murky and nearly illegible, gives the composition an irregular rhythm and an awkward painterliness that refer to Abstract Expressionism.

Troy Diptych coalesces Warhol's efforts to work through formal approaches that subvert Abstract Expressionism: refuting notions of the grandiloquent painted gesture (through repetition and regimentation), puncturing the primacy of the single large

canvas (presenting two conjoined canvases as one), and under-mining the idea of spontaneity (through the applied layers of silk-screen pigments). Warhol's painting is engaged in an agon with Abstract Expressionism, and as much as he questioned its premises, it was, of course, from the currency of what critic Harold Rosenberg called action painting that Warhol's work derived its generative potency—and mastered its essence. If Rosenberg cast the action painter's creative process as an existential battle, writing in his defining 1952 essay that "the Painting itself is a 'moment' in the adulterated mixture of [the painter's] life,"[3] for Warhol the pro-cess of making painting was more deliberate, akin to the method of a collagist assembling an inventory of gestures.

Warhol recounted in his autobiography: "In August '62 I started doing silkscreens. The rubber-stamp method I'd been us-ing to repeat images suddenly seemed too homemade. . . . With silkscreening, you pick a photograph, blow it up, transfer it in glue onto silk, and then roll ink across it so the ink goes through the silk but not through the glue. That way you get the same image, slightly different each time. It was all so simple—quick and chancy."[4] If Warhol outlined his technique in flip terms, the actual making of the paintings was more complicated. In order to generate the imagery of movie stars in his early portrait paint-ings, he used a combination of multiple silkscreen applications, combined with overpainting. In works such as *Troy Diptych* and *Marilyn x 100* (1962), "Warhol printed a preliminary impression of the black screen for each image," Georg Frei and Neil Printz note in their recent catalogue raisonné. Calling this initial print-ing a kind of "underdrawing" that was then painted over, they note that "a second and final impression was made over the color, sandwiching the color between two black screens."[5] In the yellow of Monroe's hair in *Marilyn x 100*, for example, the faint impres-sion of the first screen shows through. The residual painterly ef-fect is a direct consequence of the second applications not exactly lining up with the initial impressions. Although Warhol may have characterized his method as "quick and chancy," the painting oc-curred in calculated layers, with the initial "figure" preceding the painted "ground," followed by overprinting of the "figure."[6] The result of this process is that the subject matter is situated in, as opposed to on, the surface of the painting.

Throughout 1961 Warhol had been working on these ideas, endeavoring to deconstruct Abstract Expressionism. Works such as *Peach Halves* (1961; fig. 9) take as their subject matter adver-tisements that Warhol tore from a magazine and then limned in an "intentionally dilettantish and incomplete" manner, as Rainer Crone, one of his earliest and most perceptive appraisers, de-scribed the "alienating" of Abstract Expressionist stylistic con-ventions.[7] Although the words "peach halves" are legible, the Del Monte logo is not; its dual shades of orange become the source of several drips, which sardonically refer to the gesturality of action painting. The green tin that centrally hovers against the ground of the canvas is surrounded by black, green, and tan painterly forms, which seem abstract or random. Yet these forms are actually

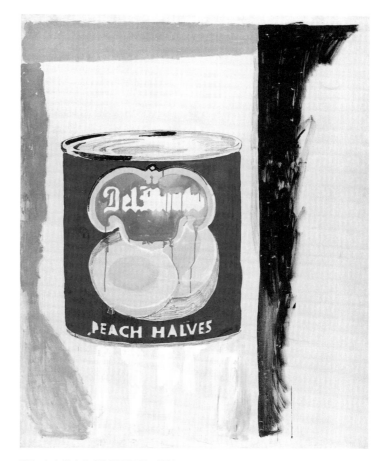

FIG. 9—Andy Warhol PEACH HALVES 1961 casein and wax crayon on linen 70 x 54 in. (177.8 x 137.2 cm) Staatsgalerie Stuttgart

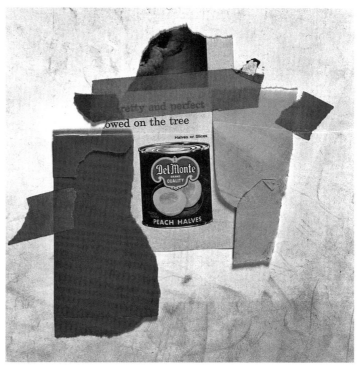

FIG. 10—Andy Warhol PEACH HALVES 1961 collage 13 1/2 x 10 3/4 in. (34.3 x 27.3 cm) The Andy Warhol Museum, Pittsburgh. Founding Collection, gift of Thomas Ammann Fine Art, Zurich

3—Harold Rosenberg, "The American Action Painters," ART NEWS 51 (December 1952): 23.

4—Andy Warhol and Pat Hackett, POPISM: THE WARHOL '60S (New York: Harper & Row, 1980), 22.

5—Georg Frei and Neil Printz, eds., THE ANDY WARHOL CATALOGUE RAISONNÉ: PAINTINGS AND SCULPTURE, 1961–1963, vol. 1 (London: Phaidon, 2002), 205. Frei and Printz note that technically "the problem became one of registration: How to determine the shape and where to place the floating forms of hand-painted color so that they would fuse with the superimposed layer of the silkscreen" (204–205).

6—In a review of Warhol's 1962 exhibition at the Stable Gallery, in which such paintings were first shown, formalist critic Michael Fried surmised the painter's technique: "I'm not sure about this, but it seems as if he laid down areas of bright color first, then printed the silkscreen pattern in black over them and finally used paint again to put in details" ("New York Letter," ART INTERNATIONAL 6 [December 20, 1962]: 57).

7—Rainer Crone, ANDY WARHOL (New York: Praeger, 1970), 23.

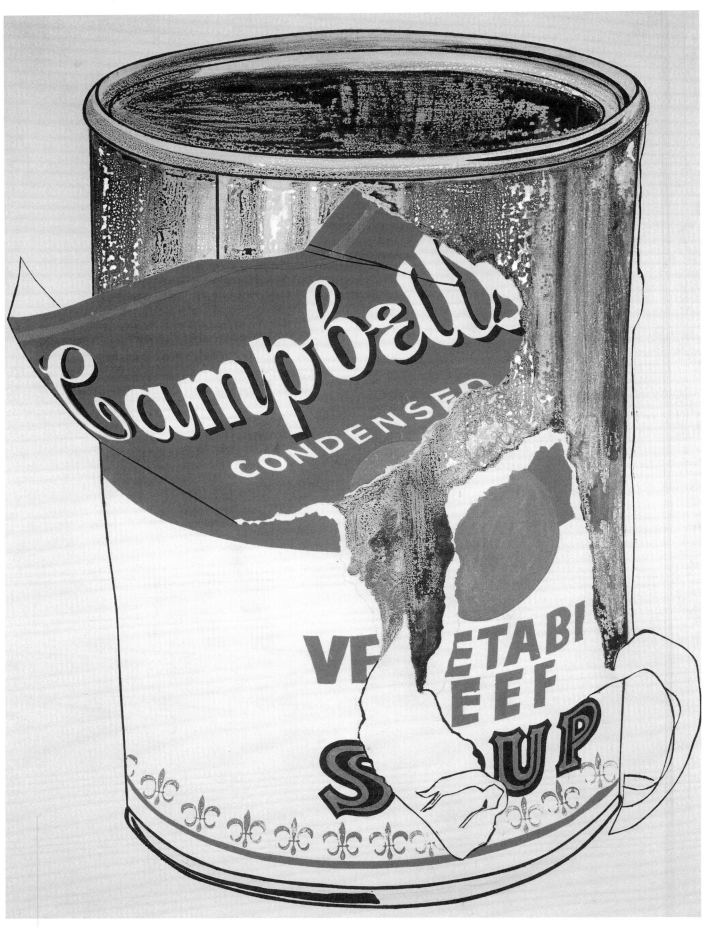

FIG. 11 — Andy Warhol BIG TORN CAMPBELL'S SOUP CAN (VEGETABLE BEEF) 1962 casein, gold paint, and pencil on linen 72 x 53 ½ in. (182.9 x 135.9 cm) Kunsthaus, Zurich

derived from a preparatory collage (fig. 10). Perhaps because of his prior professional experience as a commercial artist, Warhol used a pasteup method to organize his subject matter at this time. If one compares the collage with the finished painting, it is evident that painterly forms such as the brushy green edge at the left replicate the torn-paper collage. The tan band across the top is a painted rendition of masking tape that Warhol used to affix his pictorial elements—the torn magazine advertisement and colored paper—to a white backing board. Works such as *Peach Halves* reveal his highly constructed, even methodical means of painting.

Collage emerges as the organizing principle of how Warhol conceived and created painting. Unlike the action painter's method—Rosenberg characterized the process of painting as "putting forms into motion" and invoked the "painter's muscles" to conjure rapid movement—Warhol's method is rooted in the much slower temporality of collage. The paintings that led up to his use of silkscreen indicate his preoccupation with forcing the procedures of collage onto the smooth surface of canvas. In several series of works from early 1962 immediately preceding the advent of the silkscreen and Warhol's embrace of star and disaster imagery, he explicitly painted collage subject matter. *Big Torn Campbell's Soup Can (Vegetable Beef)* (1962; fig. 11), one from a sequence of large-format canvases, depicts the iconic Campbell's label partially peeled from the can, assertively torn, yet still recognizable. Through the title of the painting, Warhol emphasized the tearing of the paper label, a primordial act of collage that refers

to *papier déchiré*, summoning precedents that include Pablo Picasso, Kurt Schwitters, and Robert Motherwell.

Warhol's choice of subject matter and his modes of articulation in early 1962 narrate the parameters of collage. The S & H Green Stamps, Airmail Stamps, and Shipping and Handling Labels series relied upon the "rubber stamp method," which involved Warhol actually carving the designs of stamps and labels into art-gum erasers and then pressing the motif, in the manner of monoprinting, onto the surface of the canvas. Several small-scale Airmail Stamp paintings (fig. 12) elucidate his preoccupation with collage, for each is a painting of a basic collage: a seven-cent U.S. airmail stamp affixed to a white envelope. These smooth paintings of collage elements set up the matrix for the silkscreen paintings, both formally and discursively. How collage would inform Warhol's understanding of the silkscreen determined an important aspect of the paintings' discursive meaning.

The advent of the silkscreen coincides with Warhol's shift in subject matter, away from consumer goods toward the images of movie stars such as Troy Donahue, Natalie Wood, and Warren Beatty. When, in early August 1962, Marilyn Monroe committed suicide, Warhol focused extensively on the starlet, undertaking a sustained memorial.[8] For several months he worked through the motif of Marilyn: isolating "her beautiful face," as he called it, against a gold ground; testing her visage against different-colored grounds that were named for flavors (cherry, licorice, mint, etc.); serially displaying her likeness against vast expanses of canvas; picturing her ethereal face in intimately scaled halolike tondos.

Of the thirty-seven canvases in this initial engagement with Monroe, the final painting is *Marilyn Monroe's Lips* (1962; pl. 3)—two conjoined canvases that present the excised detail of the actress's lips and teeth. This work crystallizes the collage aspect of Warhol's thinking. By using the mouth, a detail from a larger image, he presents a nearly abstract signifier that stands in both for Marilyn and for his intention as a painter. In *Marilyn's Lips* the expression is difficult to read, the lips and teeth caught decontextualized—a final, flexible utterance. The extreme detail, extracted from the image of her face, elucidates Warhol's act of cutting out, of cropping the image to the point where it becomes a glyph used to structure the field of painting. He arrayed the lips on two canvases: the black mouth on a gray ground on the left canvas and the black, red, and white mouth set within a flesh pink field on the right. Warhol wanted to dissolve his subject matter into the surface of his canvases, aiming for a continuous smoothness in which the figure was at one with the ground. The binary split between black-and-white and colored impressions is meant to show us that there is no difference in surface, that the image is seamlessly integrated into the field regardless of shifts in color.

In these early silkscreen works Warhol takes up the originary meaning of collage that Picasso initiated in his *Still Life with Chair Caning* (1912), in which the artist famously affixed to the canvas a piece of oilcloth overprinted to imitate chair caning. But whereas the Cubists' application of extraneous objects and materials to the canvas (Picasso said, "We sought to express reality with materials we did not know how to handle"[9]) resulted in a layered surface, Warhol's surface is seamless and smooth. The paintings

33

8—Thomas Crow noted the funereal nature of the Marilyn paintings in "Saturday Disasters: Trace and Reference in Early Warhol," ART IN AMERICA 75 (May 1987): 128–136.
9—Quoted in John Golding, CUBISM: A HISTORY AND AN ANALYSIS, 1907–1914, 3rd ed. (Cambridge: Harvard University Press, 1988), 105.

are all image, not object and image in the sense of classical Cubist collage or the mock-ups that Warhol used for works such as *Peach Halves*. Warhol recognized the scope of this insight (which immediately distances his painting from the more object-oriented and textured work of Jasper Johns and Robert Rauschenberg) and signaled that he was explicitly thinking about collage by cutting the canvas in half.

Warhol painted *Marilyn's Lips* on one continuous bolt of canvas. A 1963 film clearly reveals that for months after the work was painted, the rolled canvas remained uncut in his studio.[10] Thus, in an ultimate act of collage, Warhol sliced the work in half and then reassembled it, conjoining the two panels as one work. By splitting the canvas in two, he internalized the otherness of collage, a move that he adeptly deployed in Death and Disaster compositions such as *Mustard Race Riot* (1963) and in major portrait paintings such as *Elvis I and II* (1963; pl. 49). In these works the smooth imagery is interrupted by the seam that divides the two canvases. By cutting the canvas, Warhol co-opted collage's most transgressive gesture and fractured the large-scale, unified canvas of modernism—the so-called arena in which Abstract Expressionism achieved greatest articulation. To perform collage in a two-dimensional surface was radical, and it is in this impacted surface that Warhol astutely located himself. "If you want to know all about Andy Warhol, just look at the surface of my paintings and films and me, and there I am," he stated in 1967. "There's nothing behind it."[11] The works are all surface: figure and ground, image and paint, artist and artifact.[12] How one begins to identify Warhol becomes a balancing act between image content and the articulation of painting.

Warhol quickly understood the significance of the collapse of space and materials that silkscreen afforded and rhetorically produced a series of 3D paintings that he intended viewers to experience with the aid of red and green glasses, a cinematic fad at that time. *Optical Car Crash* (1962; fig. 13), which closely followed *Marilyn Monroe's Lips*, is the first painting to graphically treat disaster subject matter, and it dramatizes in an explicit manner Warhol's notion of the smooth surface that always irreducibly puns on depth. In order to achieve the 3D effect, he printed the image first in phthalo green and then again, intermittently, in cadmium red light.[13] The repeated, overprinted image of the car crash victim consumes the entire pictorial field and eerily hovers, with or without the aid of the enhancing glasses, animated by the whiteness of the canvas. This play on flatness is Warhol's signal that the silkscreen technique subsumes the spatial connotations of collage. By picturing the illusion of depth, he allows everything that he and his art are about to become transacted *as* sheer surface.

In *Mustard Race Riot*, Warhol coupled images of civil rights protestors being attacked by police dogs with a monochromatic canvas. The photographic depth of the street, which metaphorically becomes the battleground of American democracy, contrasts with the void of the empty canvas. Here, as in many of the Death and Disaster paintings, the imagery is grainy, at times offering only ghostly traces of an image, which the silkscreen reduces to faint differences between darkness and light. The blank canvas, which operates as pure surface, receives our disbelieving stare—questioning the narratives of these potent images, which include horrific driving accidents, graphic suicide scenes, and the unremitting motif of an electric chair.

The acuity with which Warhol premised his shocking subject matter in mainstream painterly terms is revealed if one connects the use of large monochromatic panels to the then-prevailing discourse of flatness in American painting. The appearance of the mustard monochrome in *Mustard Race Riot*, scaled to consume the viewer's vision, can be read as a sly retort to the high-minded formalism promulgated by the critic Clement Greenberg. If Greenberg declared in 1960 that "stressing the ineluctable flatness of the surface" was the unique province of modernist painting,[14] then Warhol's monochromes avail themselves of this attribute in blunt, if not literal, terms. Indeed, the notion of flatness, taken over from the color field painters, whom Greenberg had championed, contributed yet another facet to Warhol's quest to articulate the figure within the ground—to fully submerge himself in the surface of painting.

Warhol's painterly concerns brilliantly coalesced in his first exhibition of Elvis portraits, held at the Ferus Gallery in Los Angeles in September 1963 (fig. 14). For that exhibition Warhol simply shipped one continuous roll of canvas upon which he had painted, along with an assortment of wooden stretchers, from New York to Los Angeles. At the time of the installation, the enormous canvas was cut into various lengths by gallery owner Irving Blum. "Cut them any way that you think you should," Warhol told Blum: "They should be cut. I leave it to you. The only thing I really want is that they should be hung edge to edge, densely—around the gallery."[15] Some canvases contained a single Elvis image; others presented double and multiple figures of the American idol. Contemporary accounts of the exhibition mention a single thirty-seven-foot-long painting with sixteen figures of Elvis.[16] Apparently taken from a postcard picturing Presley as a cowboy in the 1960 film *Flaming Star*, a Western directed by Don Siegel, Warhol's Elvis is shown frontally, gun drawn, confronting the viewer. Printed at an imposing, larger-than-life scale, the paintings in this exhibition engulfed the viewer, consuming the space of the gallery to become a continuous "ground" against which the viewer inevitably becomes the active "figure," thus operating as a kind of ultimate collage.

The images of Elvis were printed in black against silver grounds to reflect the viewer's gaze and to assert, mirrorlike, the absence of depth. Elvis's body flickers across this metaphorical "silver screen" like an alternately projected and receding apparition, constituted by the grain of the silkscreen, at times slipping into the porous realm of shadow or stuttering to life through multiple overprintings. In these thinly printed canvases, shadows become significant, supplying the effect of depth where there is none.

In the Elvis paintings, in contrast to the faces of movie stars, Warhol used a full body that gestures toward us—the outstretched, gun-toting arm throwing a shadow across his leg,

10—In a film entitled EXHIBITION, made in 1963 by Lane Slate, the roll upon which MARILYN MONROE"S LIPS was painted is clearly visible. It is a unique work, so it is certain that the painting remained uncut until Warhol sliced it in two before its first showing in a 1965 exhibition. See Frei and Printz, CATALOGUE RAISONNÉ, vol. 1, 252.

11—Quoted in Gretchen Berg, "Andy: My True Story," LOS ANGELES FREE PRESS, March 17, 1967.

12—Brian O'Doherty, writing under the pseudonym Mary Josephson, observes: "Warhol's genius in composing his own face is that there is nothing BEHIND it. The numen of the ingenue-star is pure surface; all energies are transacted to that surface to preserve its integrity. From that surface one's glance skids and slides and returns" ("Warhol: The Medium as Cultural Artifact," ART IN AMERICA 59 [May–June 1971]: 43).

13—See Frei and Printz, CATALOGUE RAISONNÉ, vol. 1, 278.

FIG. 13 — Andy Warhol OPTICAL CAR CRASH 1962 silkscreen ink and pencil on linen 81 3/4 x 81 1/16 in. (207.7 x 205.9 cm) Kunstmuseum Basel

drawing us into the fictive space of painting. This ploy is yet another conflation of flatness and depth, which becomes magnified through the expert cropping of the image, in which the heads and feet are clipped, exceeding the edges of the canvas, spilling into and connecting with the space of the viewer.

In *Elvis I and II*, the only work in this series containing color, Warhol encoded all of the painterly tropes that can be traced through the evolution of his work in the early 1960s, from his pre-silkscreen Abstract Expressionist works that depended upon collage to the early movie star paintings that compressed notions

35

14 — Clement Greenberg, "Modernist Painting," in CLEMENT GREENBERG: THE COLLECTED ESSAYS AND CRITICISM, ed. John O'Brian, vol. 4, MODERNISM WITH A VENGEANCE, 1957–1969 (Chicago: University of Chicago Press, 1993), 87.

15 — Quoted in Patrick S. Smith, ANDY WARHOL'S ART AND FILMS (Ann Arbor, Mich.: UMI Research Press, 1986), 271–272.

16 — For a comprehensive account of this exhibition, see Frei and Printz, CATALOGUE RAISONNÉ, vol. 1, 355. See also John Coplans, "Andy Warhol and Elvis Presley," STUDIO INTERNATIONAL 181 (February 1971): 49–56.

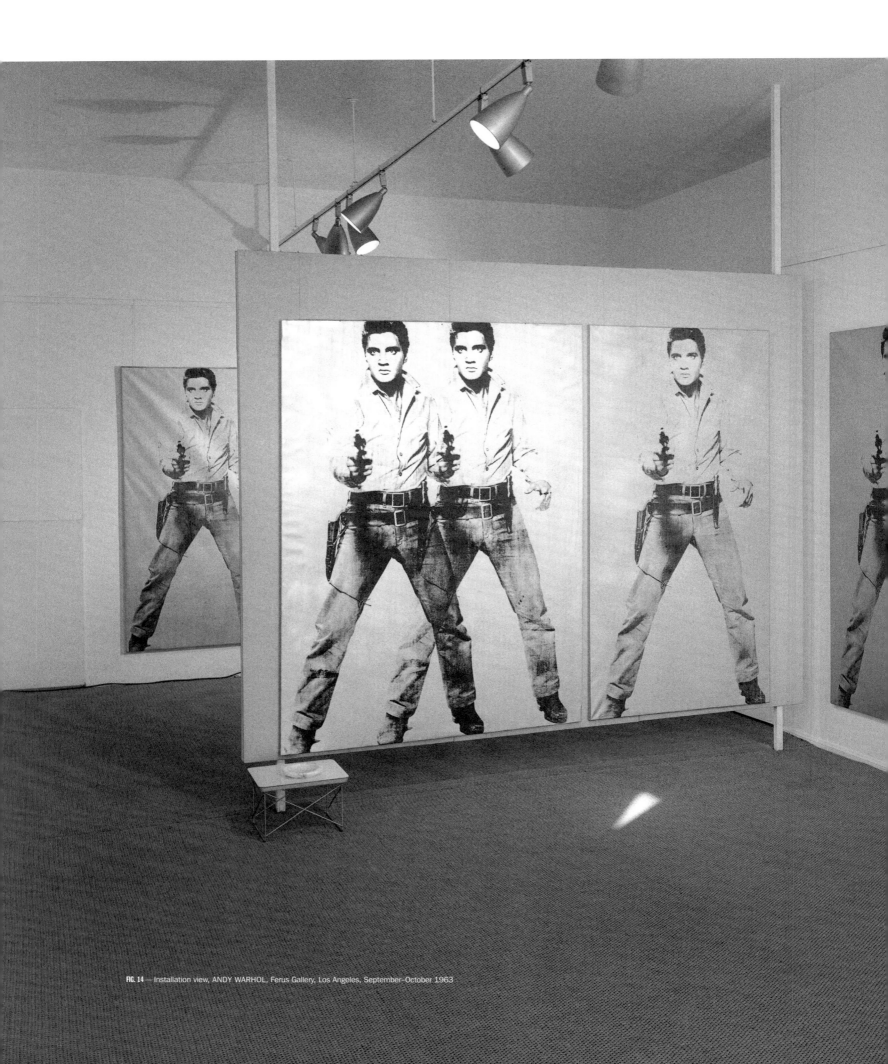

FIG. 14 — Installation view, ANDY WARHOL, Ferus Gallery, Los Angeles, September–October 1963

of depth into thinly layered fields. The colored panel of *Elvis I and II* was almost certainly painted after the Ferus exhibition. In this work, in contrast to the earlier colored movie star paintings, Warhol did not rely upon an initial underprinting. He began by painting the red shirt, purple pants, and other details of local color and then printed the black screens on top to organize the image of Elvis. He presumably then silhouetted the figures with masking tape and applied the ground, surrounding the figures in ethereal blue.[17] Numerous small blue drips suggest this method and sequence, which give the colored Elvis figures their striking, dimensional presence, appearing almost to be cut out. By coupling the two canvases of *Elvis I and II*, the painter proposed yet another solution to the elusive merger of figure and ground. By bringing the canvases together well after their production, he added a temporal dimension to his immolation of collage strategies.[18]

Warhol's painting of the early 1960s can be understood as an effort to comprehend the methods and meanings of collage. Put another way, he wanted to dissolve himself into painting, to metaphorically be both the object and the cast shadow. His choice of subject matter, which has an eerie association with death, chimes ideally with his painterly technique, exploiting flatness to paradoxically articulate depth. In the tightly cropped Jackie paintings (pls. 54, 55), for example, the grainy image of Jacqueline Kennedy's face is reduced to stark differences between light and dark. One comes to realize that this is the essence of Warhol's work as a painter, especially if one looks back at the early work from the perspective of the Shadow Paintings of the late 1970s, which code the texture of abstract shadows across expanses of canvas. When Schnabel notes Warhol's "utter denial of the sentimental," all of the subject matter tumbles into focus through this arch trope of difference conducted on a smooth plane, pure presence versus absence, persona versus death.

Warhol directed the viewer's gaze to his surface, stating that "there is nothing behind it," because he proposed so many nuanced solutions to what was *in* the surface. For many of the silver Elvis paintings, Warhol applied spray paint to animate the field—a diffuse, vaporous, and depthless ground. He appears to have been more preoccupied with ways of making paintings than commonly thought, and to feed his evident interest in new solutions to the figure-ground problematic, he continually required new subject matter. The silkscreen—the silk of the screen itself suggests the smoothness of the surface he sought for his paintings—allowed the artist to conduct light, to render his subjects as darkness posed against color. Within this metaphor one finds the painter, ever receding into the shadows of the imagery he has thrown across flat surfaces.

17—My account differs slightly from how Frei and Printz have surmised that the work was painted. They contend that "the background appears to have been painted first, around the figure, which was silhouetted in masking tape" (CATALOGUE RAISONNÉ, vol. 1, 379). I believe instead that the blue ground was painted on top of the red shirts, as small specks of blue paint on both shirts imply. There are also noticeable traces of blue on the left pant leg of the Elvis on the right. There is a slight curl to the blue paint as it outlines the legs, which further suggests this sequence—of submerging the figure into the ground.
18—This occurred soon after Warhol's exhibition at the Institute of Contemporary Art, Philadelphia, October–November 1965.

PLATES

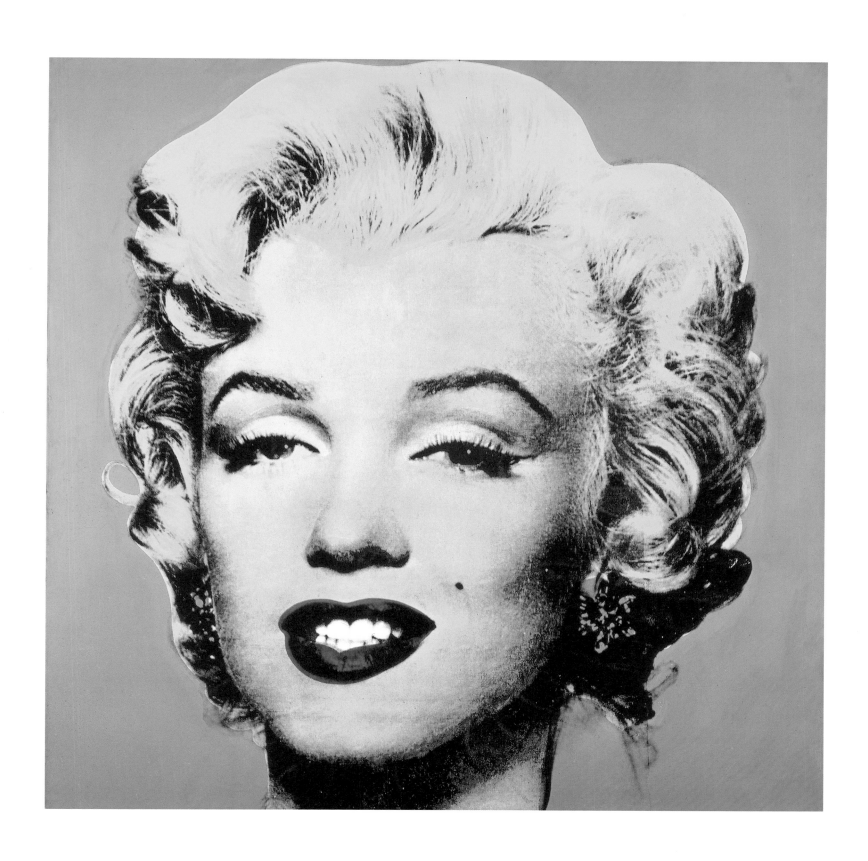

1—TURQUOISE MARILYN 1964

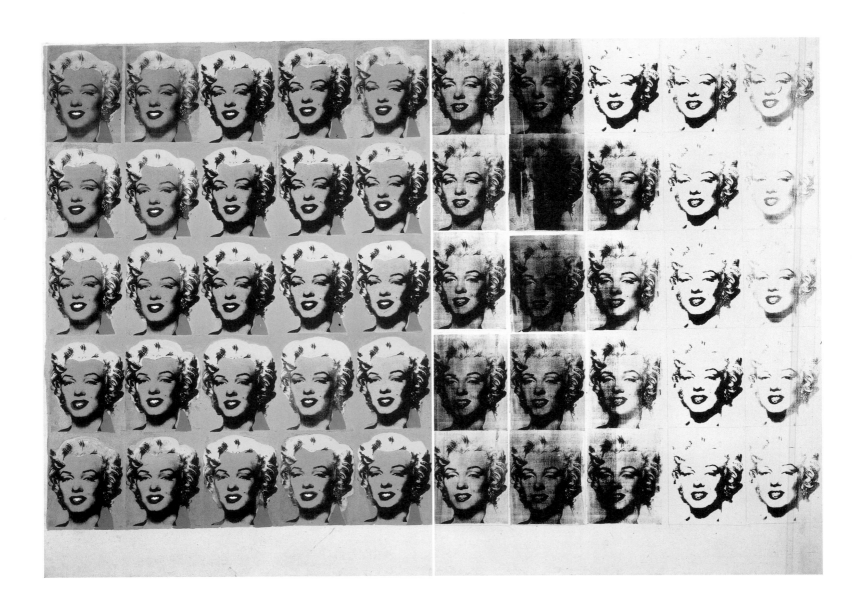

2—MARILYN DIPTYCH 1962

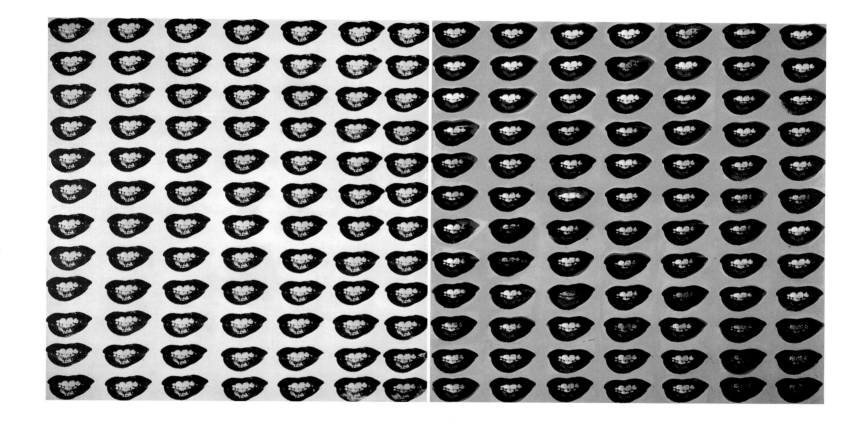

3 — MARILYN MONROE'S LIPS 1962

43

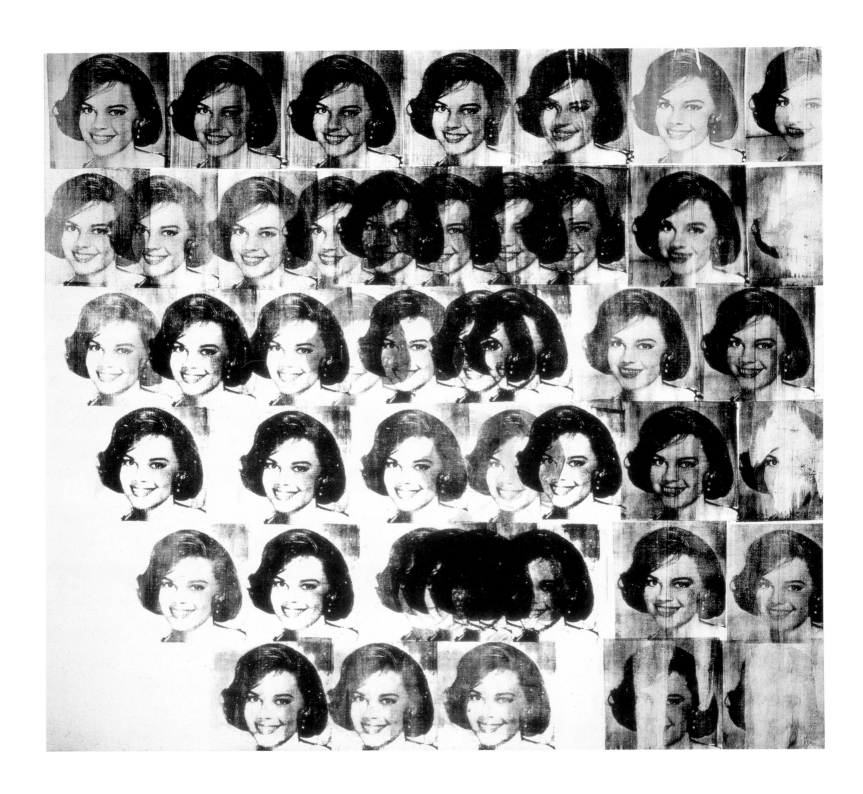

4—NATALIE 1962

44

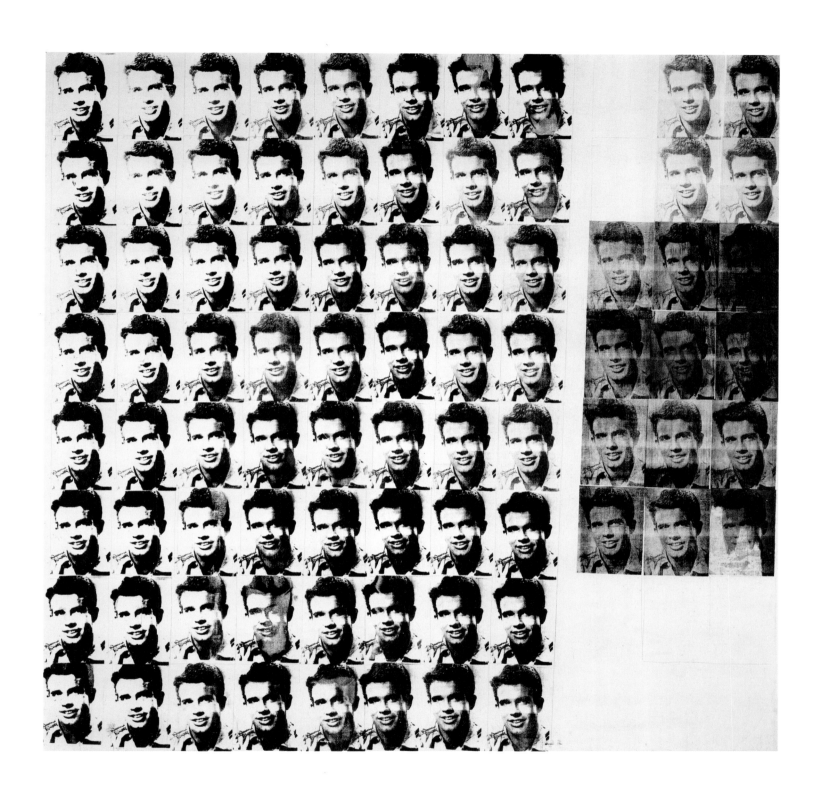

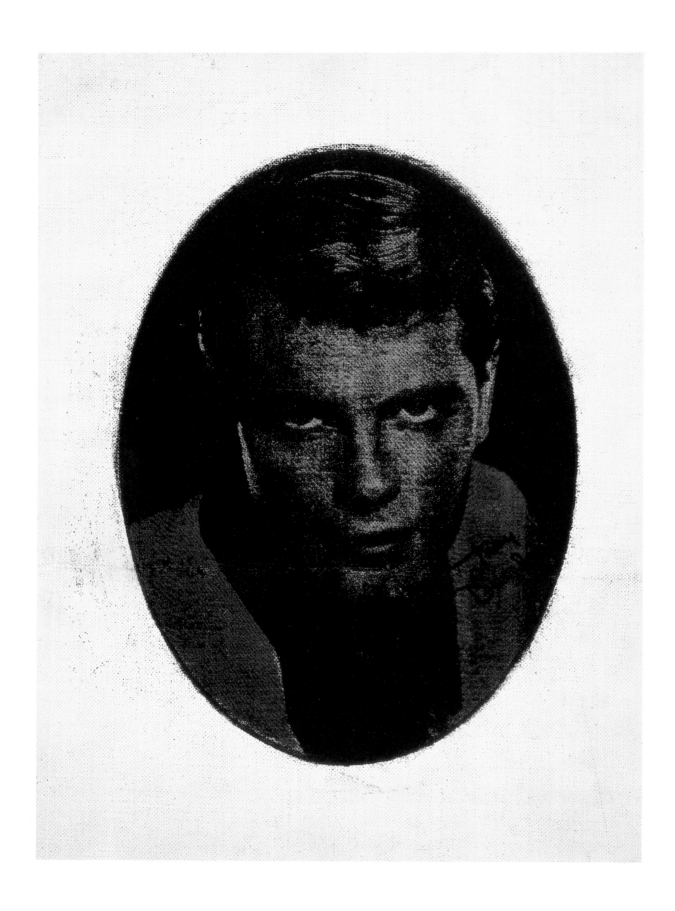

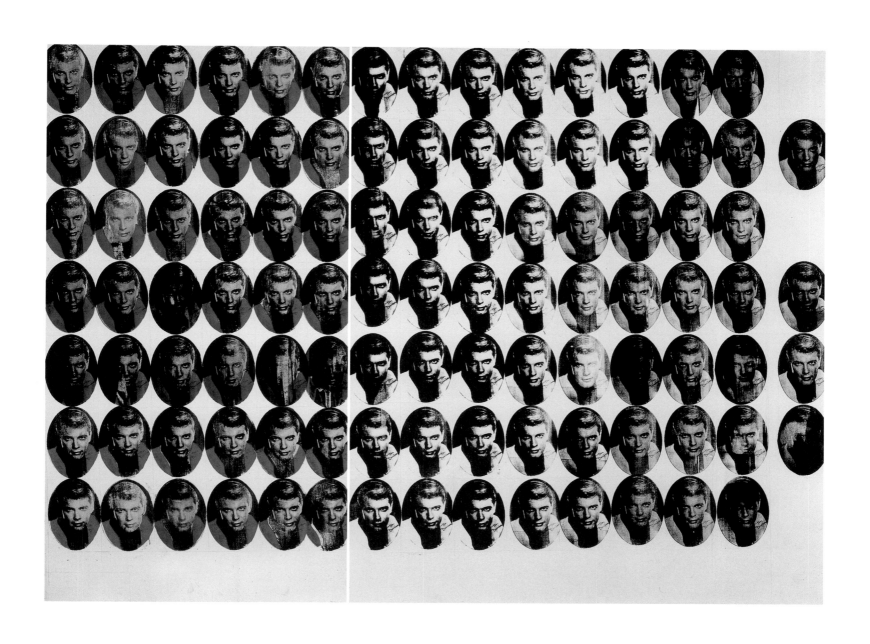

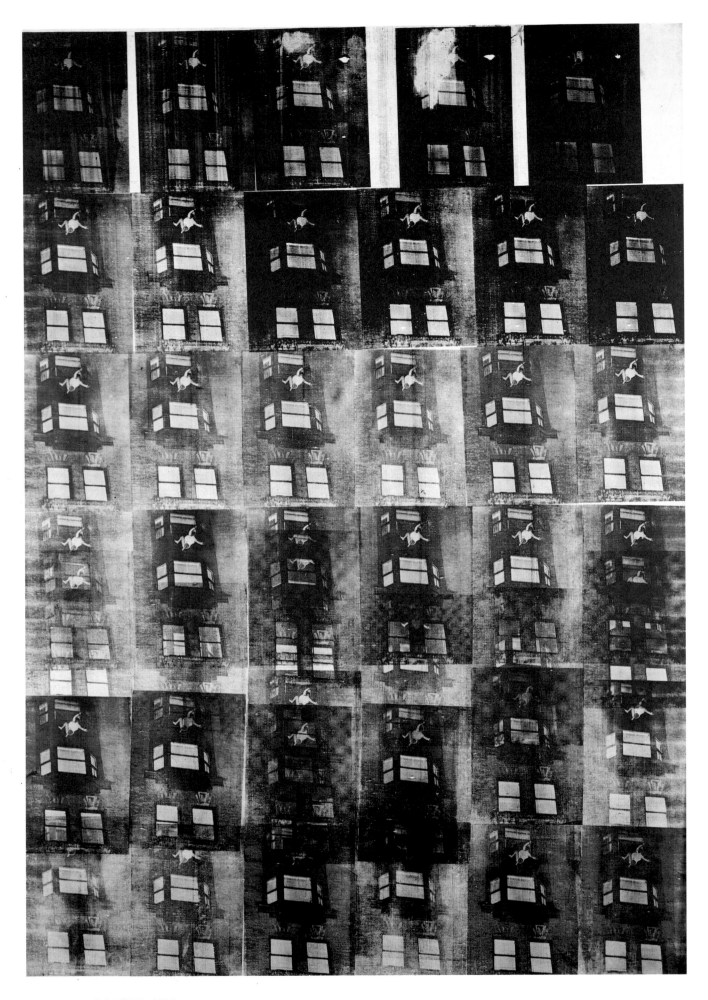

8 — A WOMAN'S SUICIDE 1962

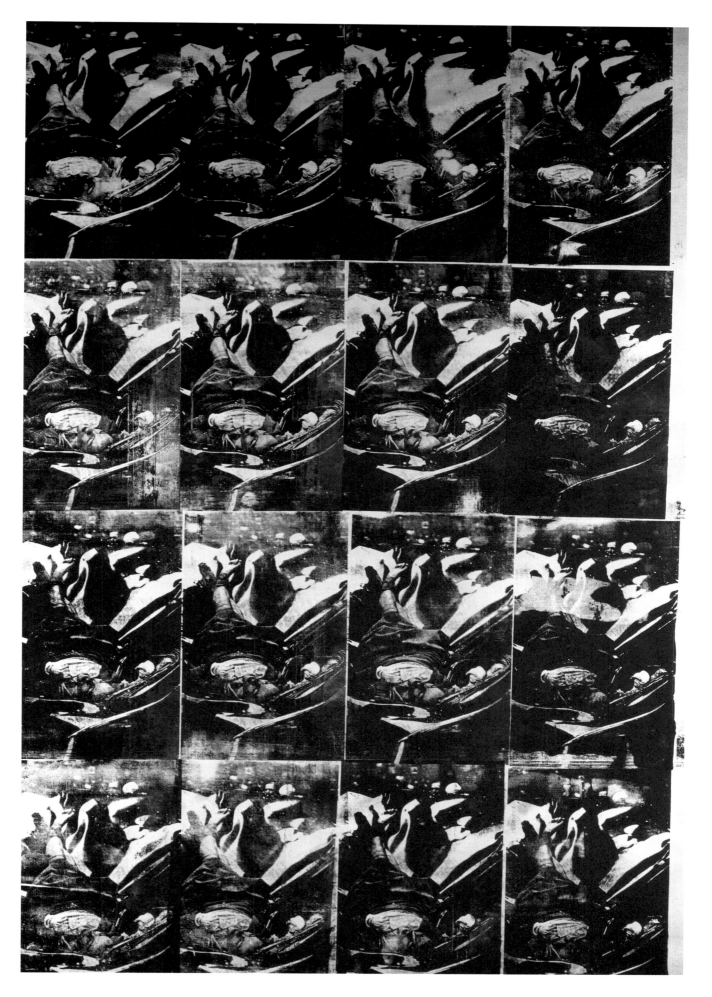

9—SUICIDE (FALLEN BODY) 1963

51

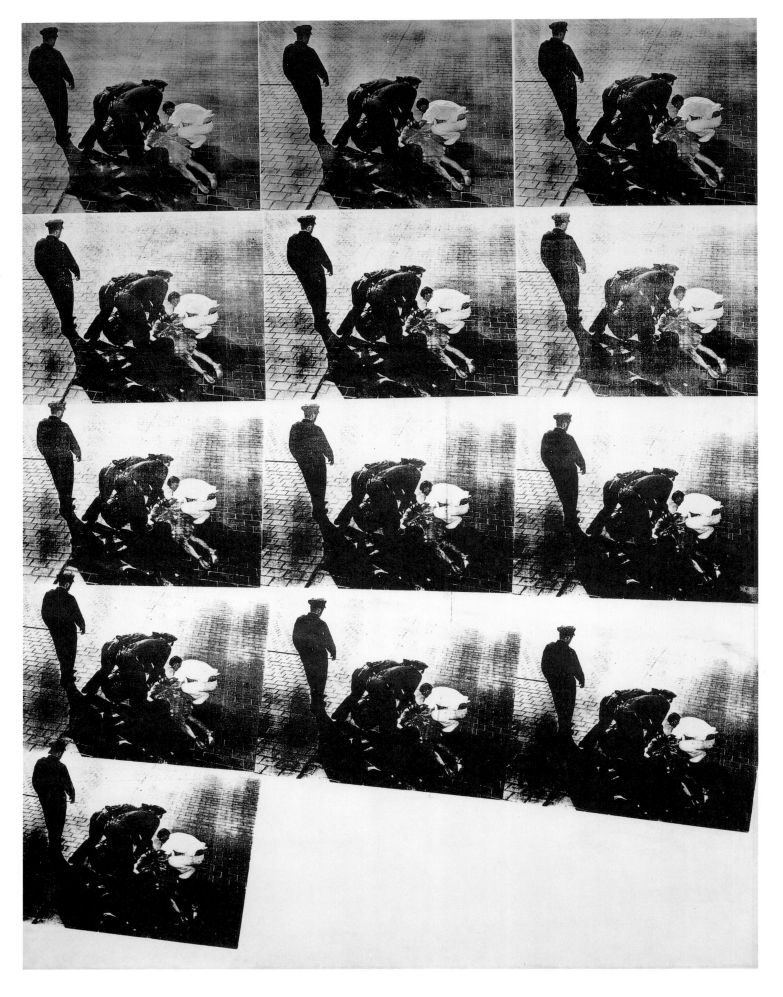

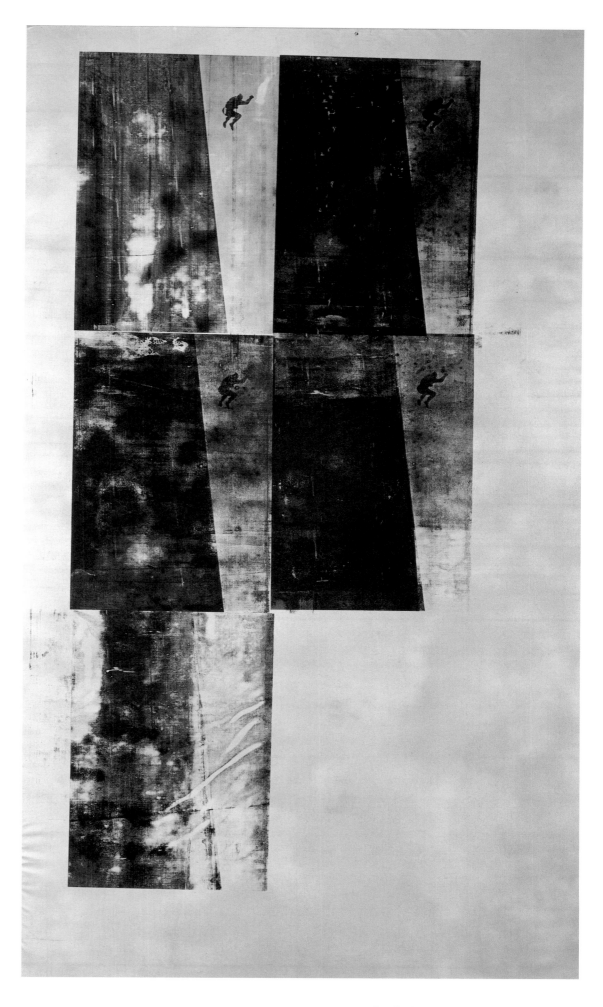

11 — SUICIDE (SILVER JUMPING MAN) 1963

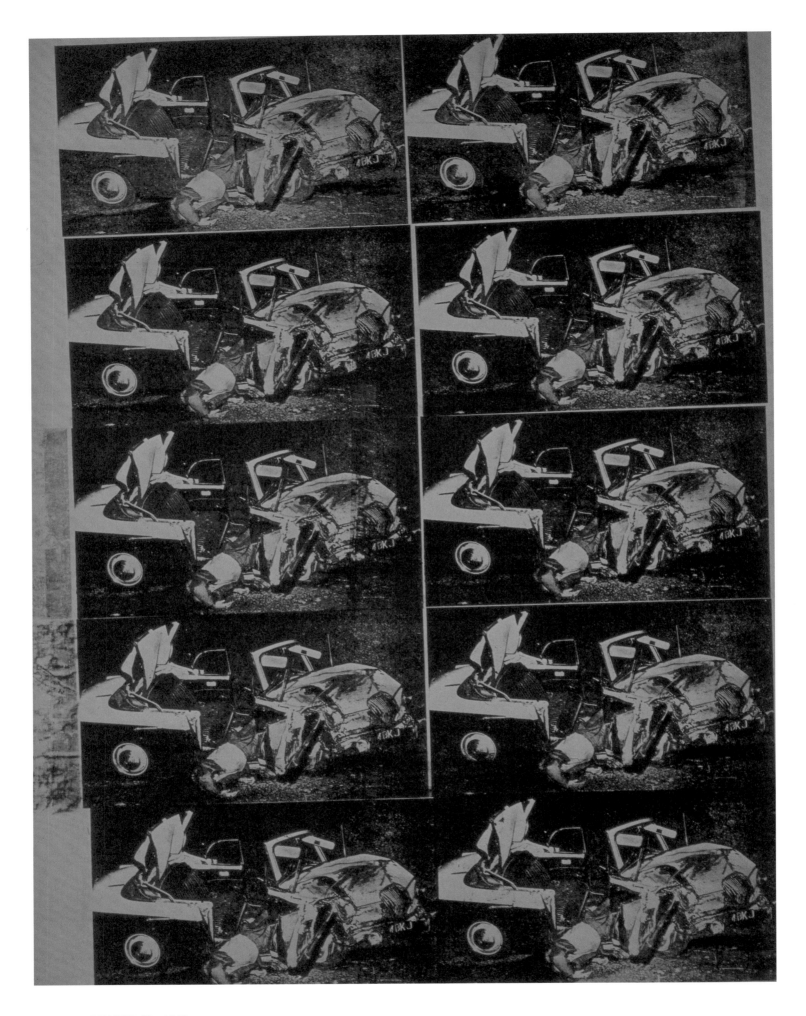

12—GREEN DISASTER #2 1963

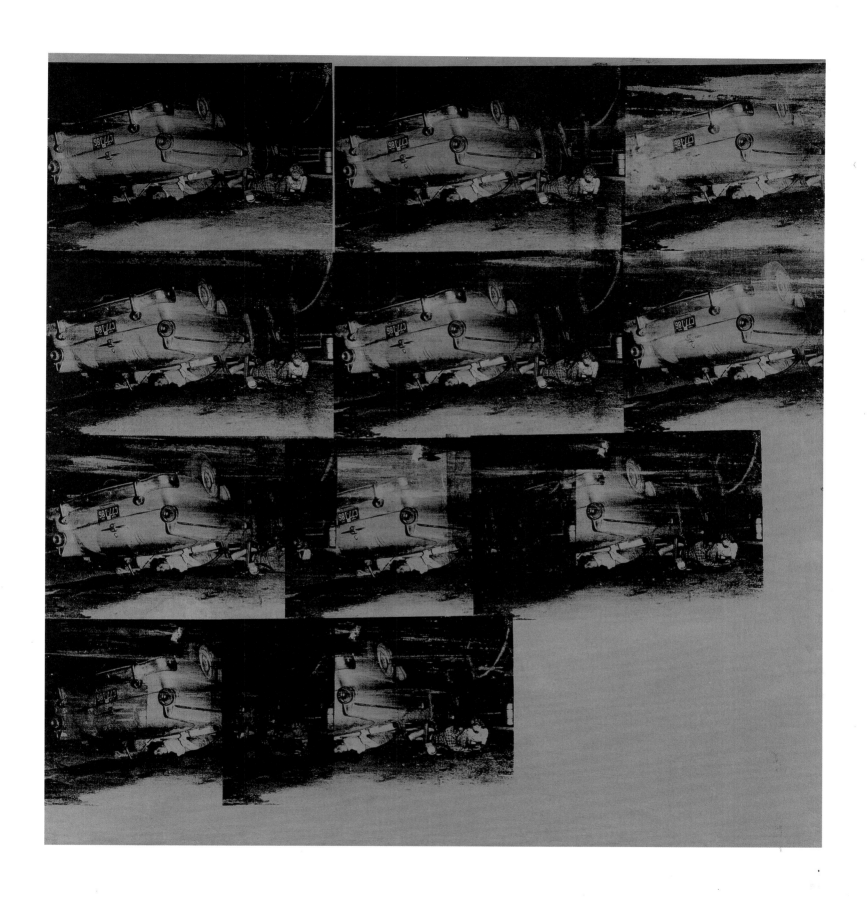

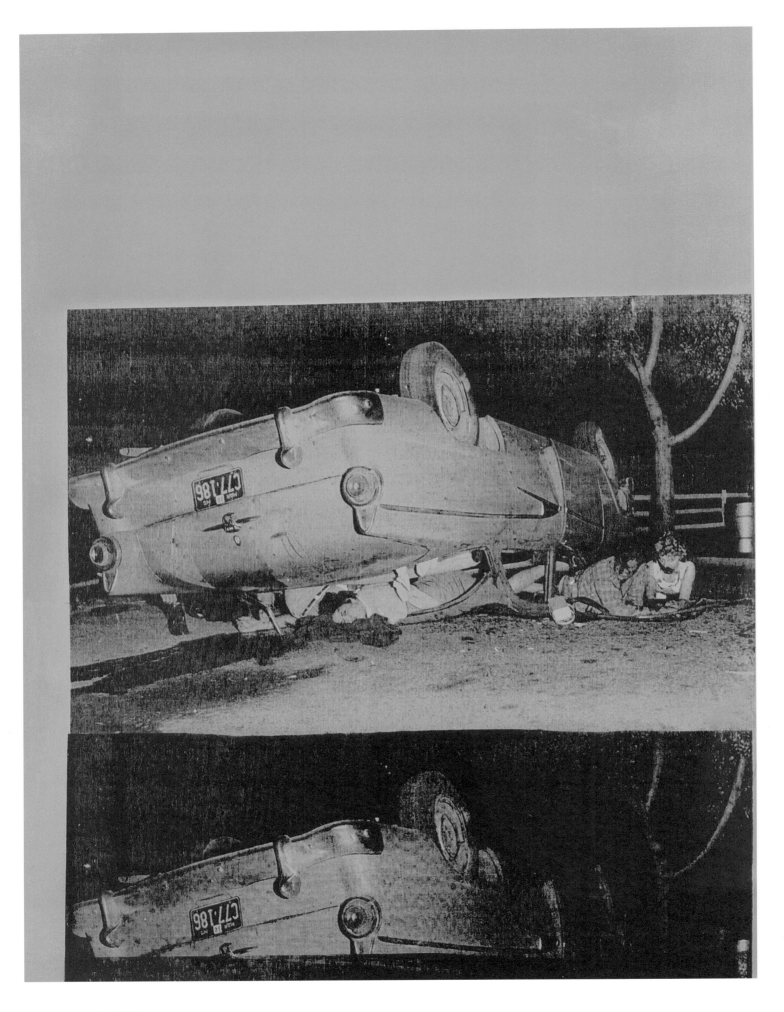

14 — FIVE DEATHS 1963

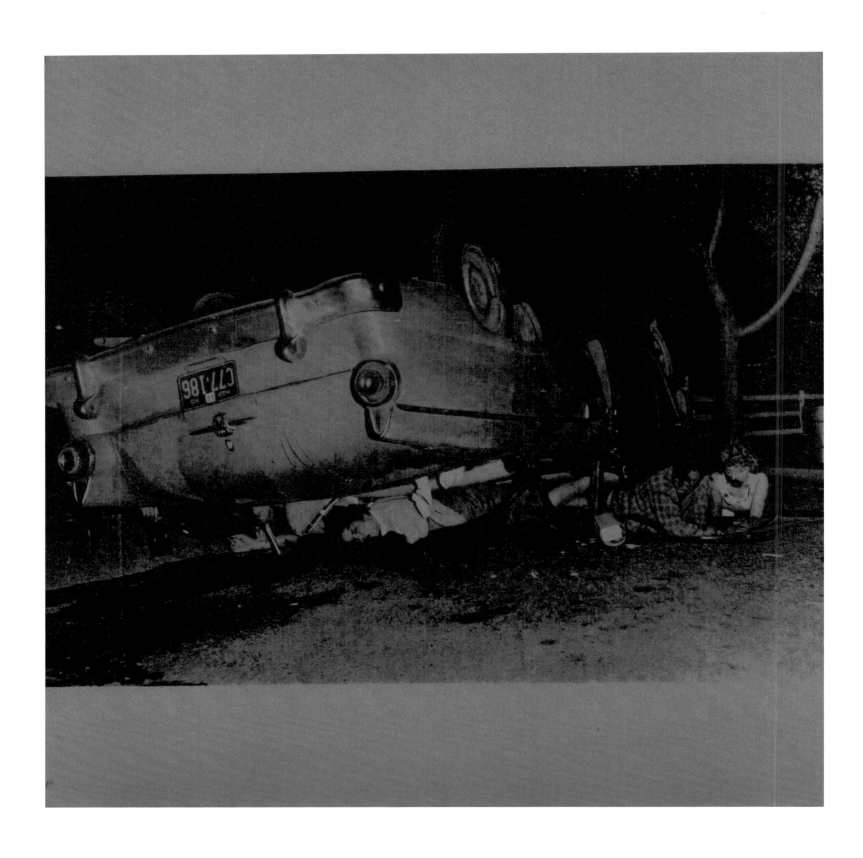

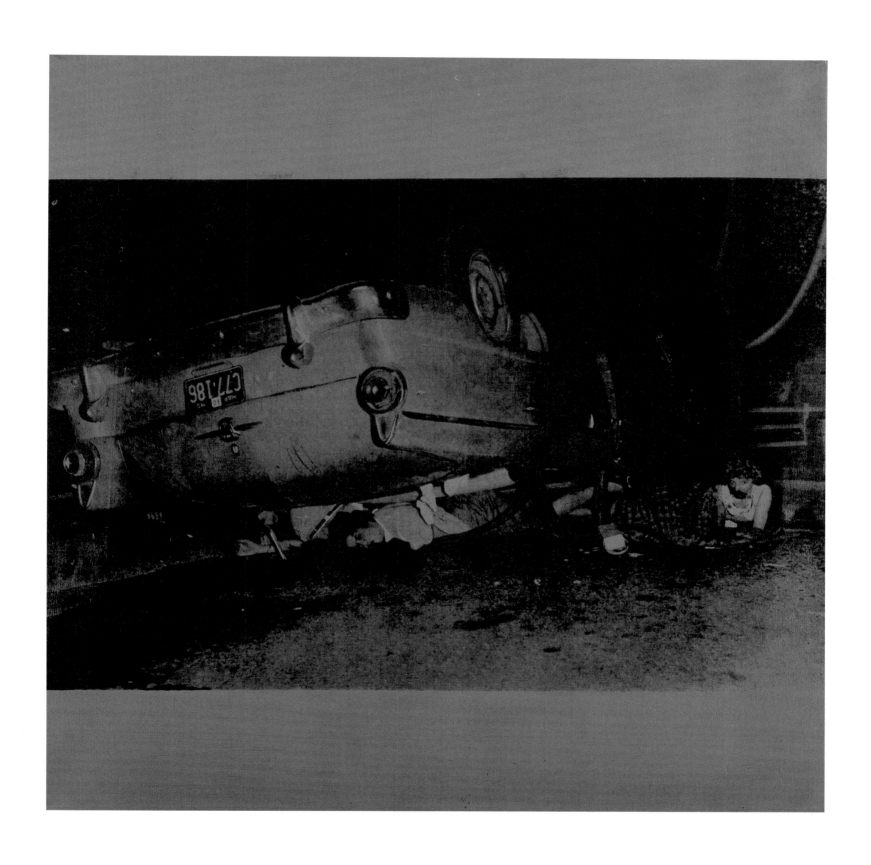

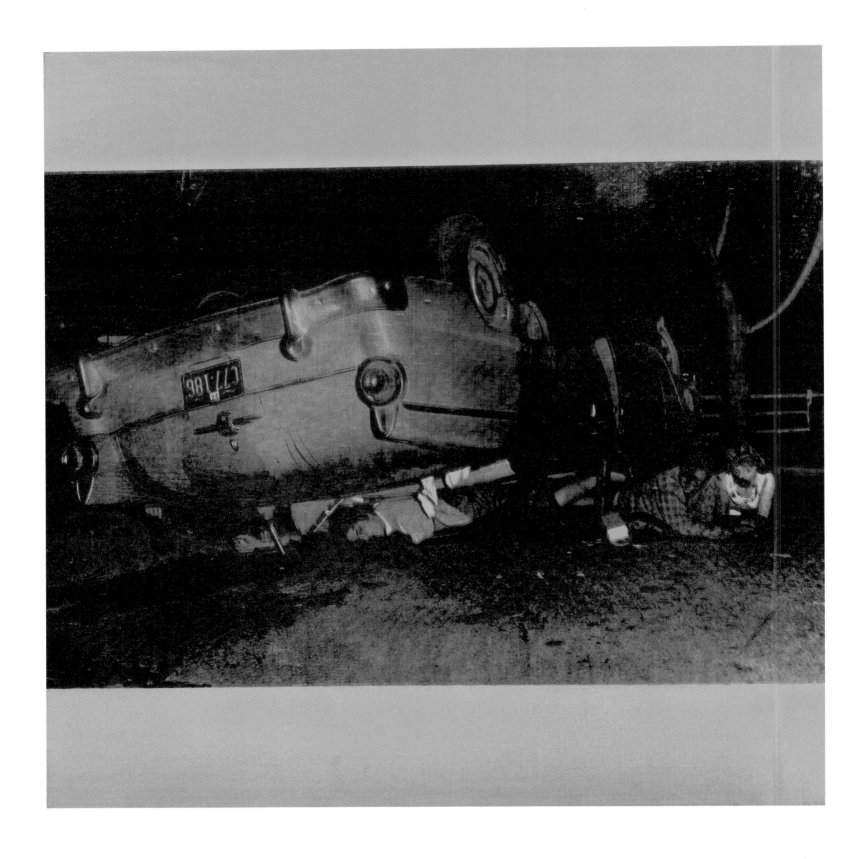

18 — FIVE DEATHS ON YELLOW 1963

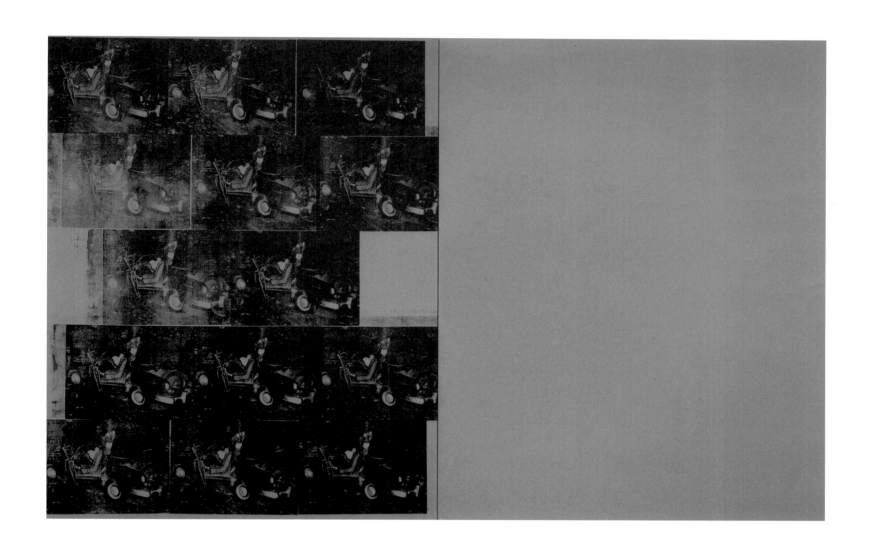

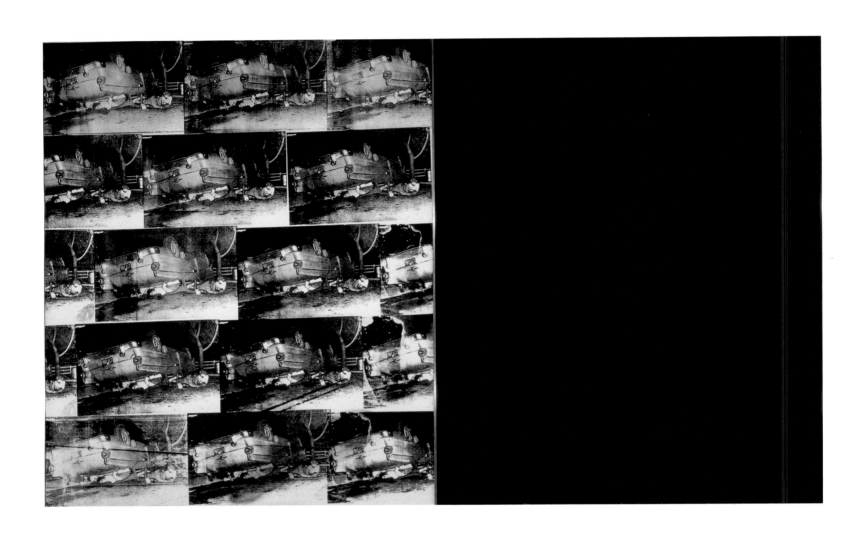

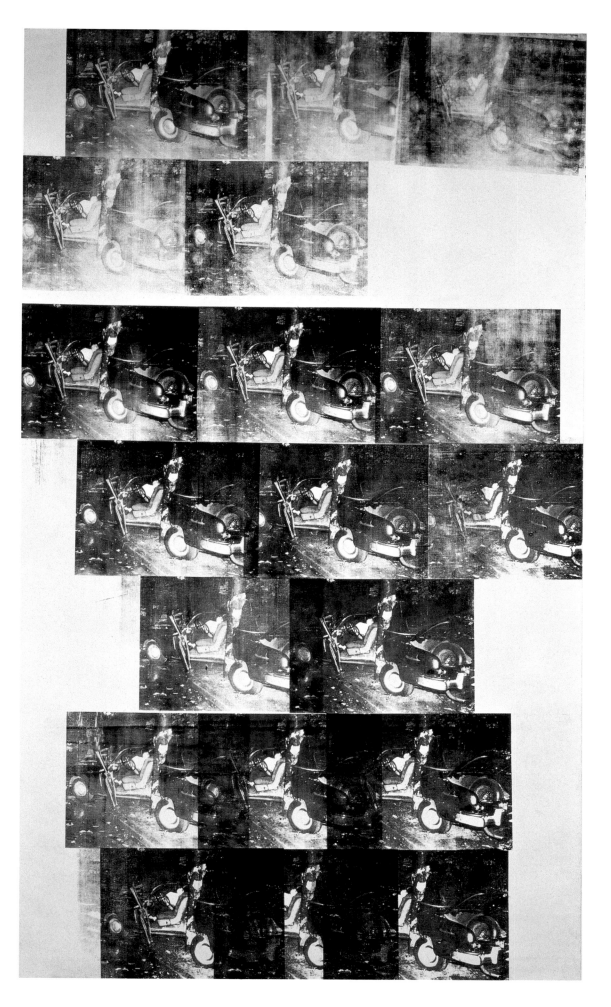

21—WHITE DISASTER 1963

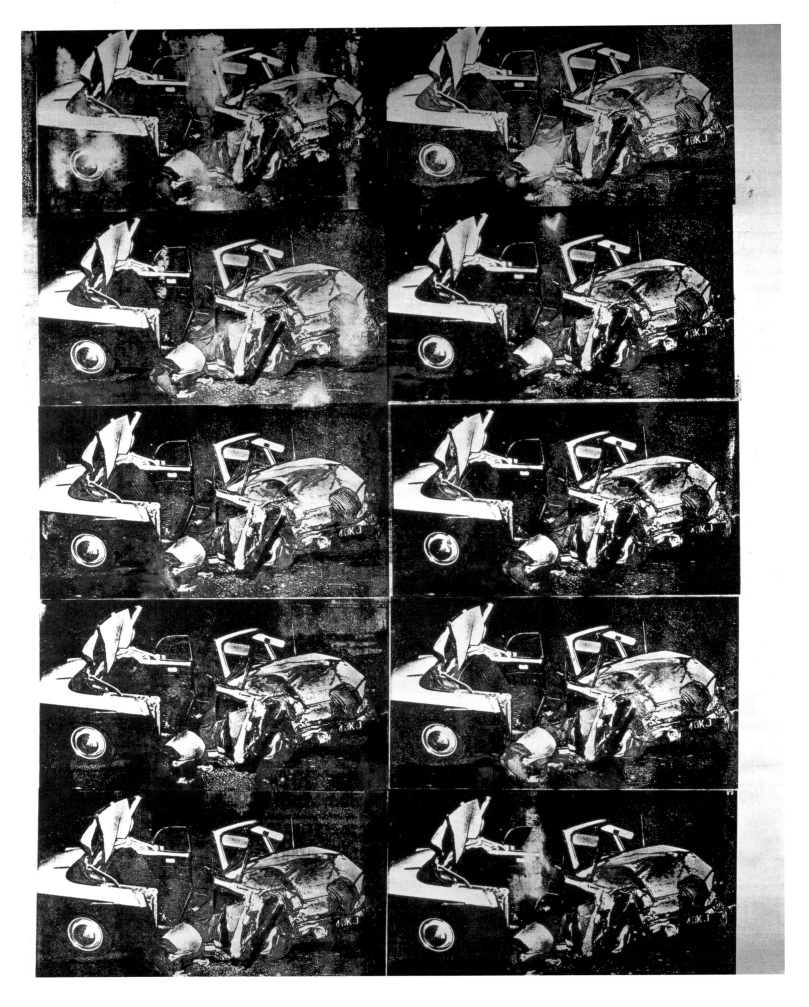

22 — SILVER CAR CRASH 1963

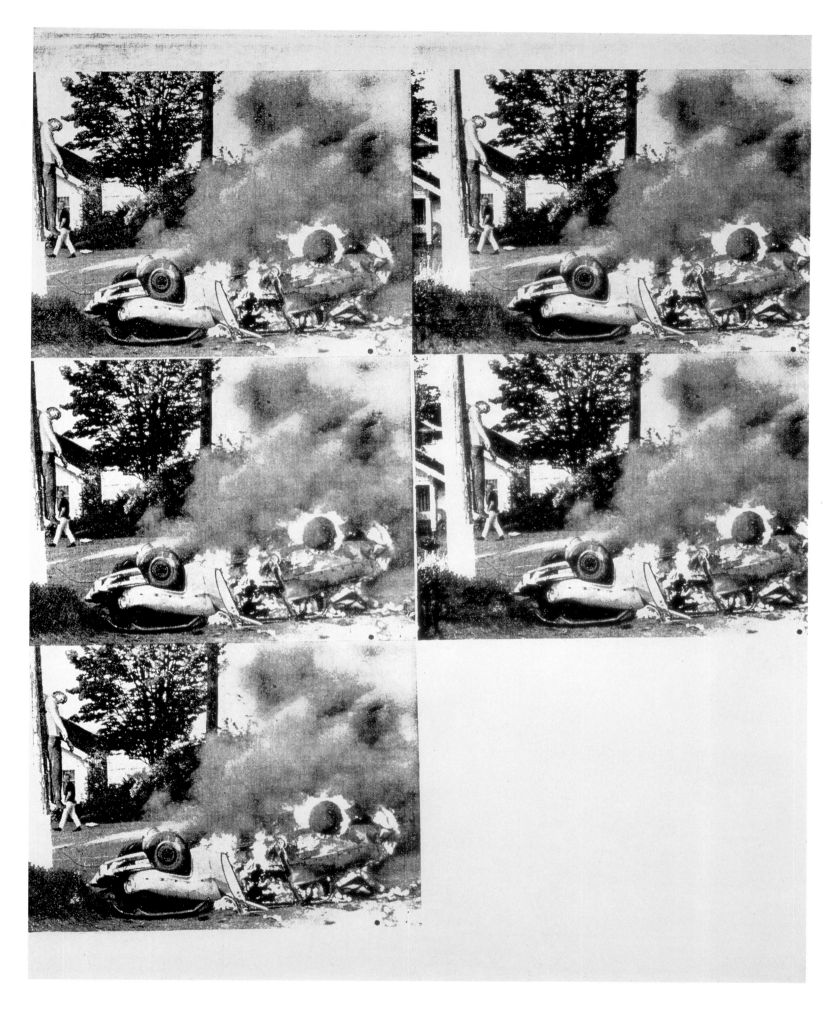

23 — WHITE BURNING CAR III 1963

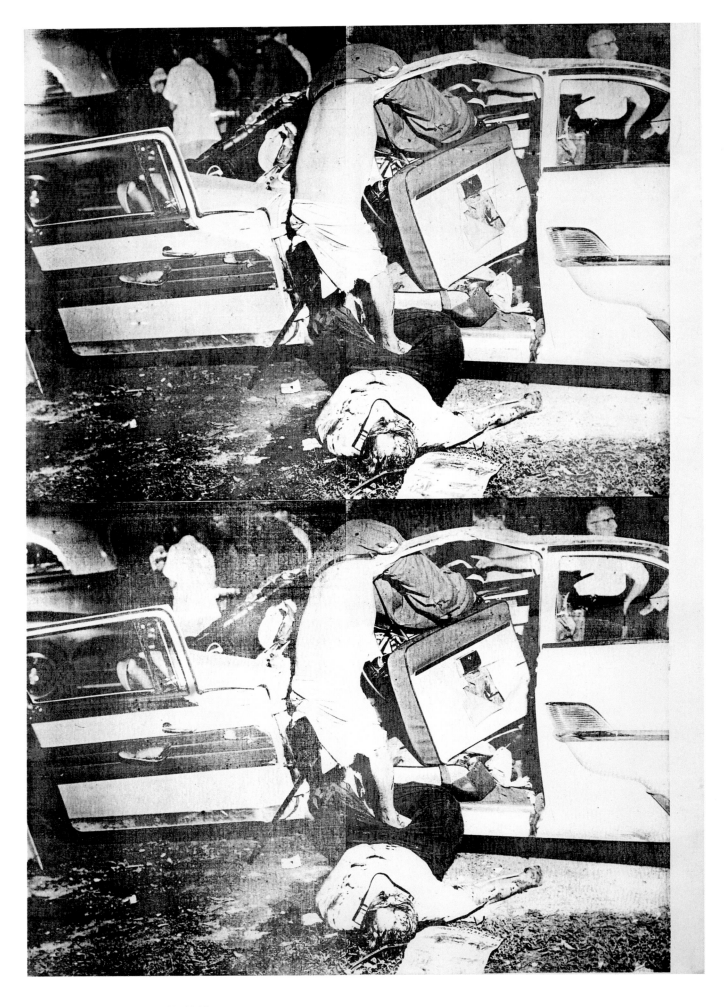

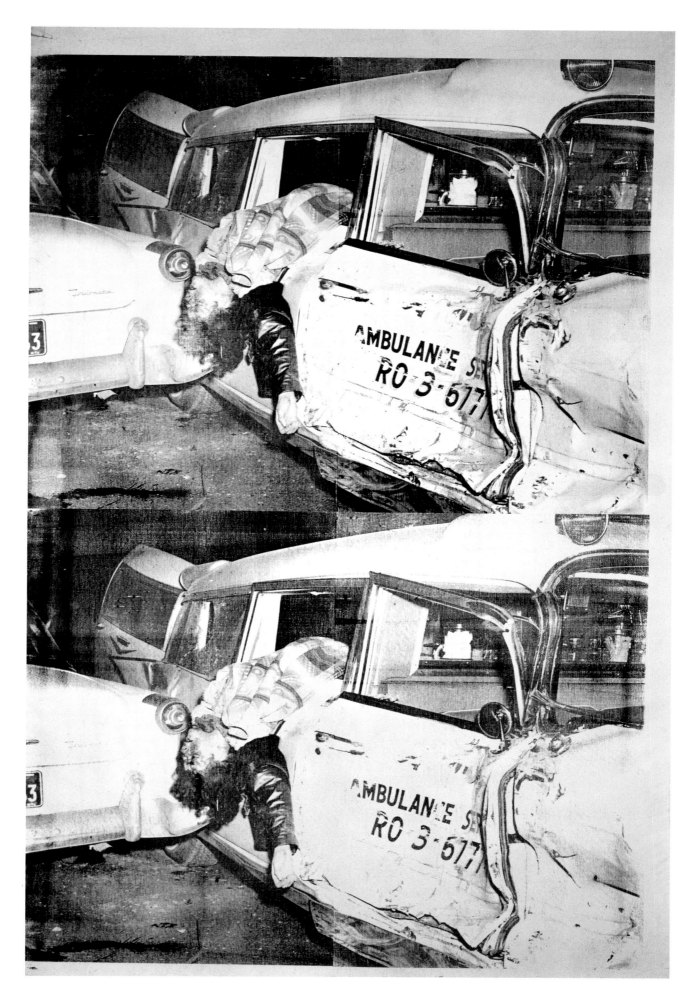

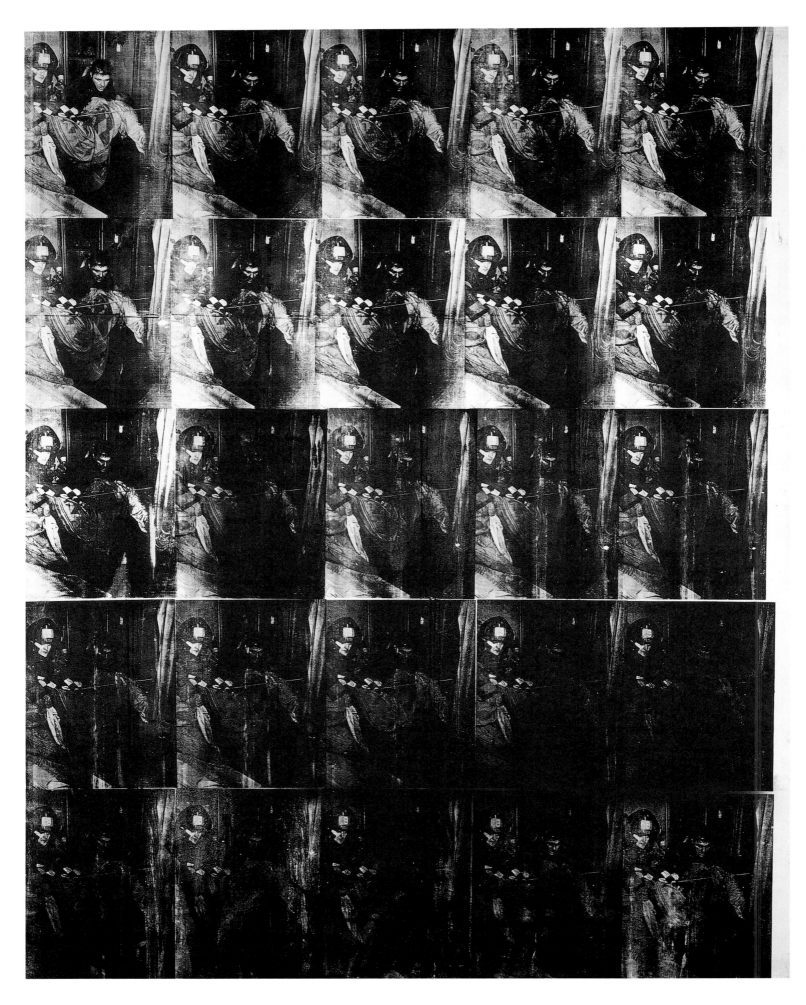

27 — BLACK AND WHITE DISASTER 1962

70

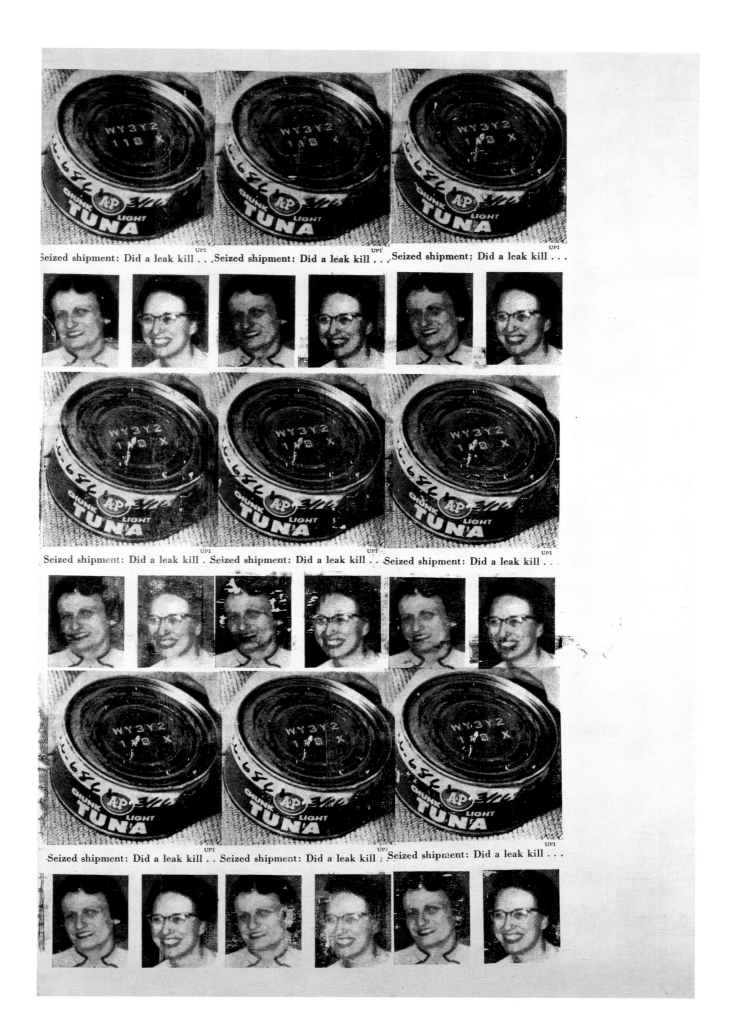

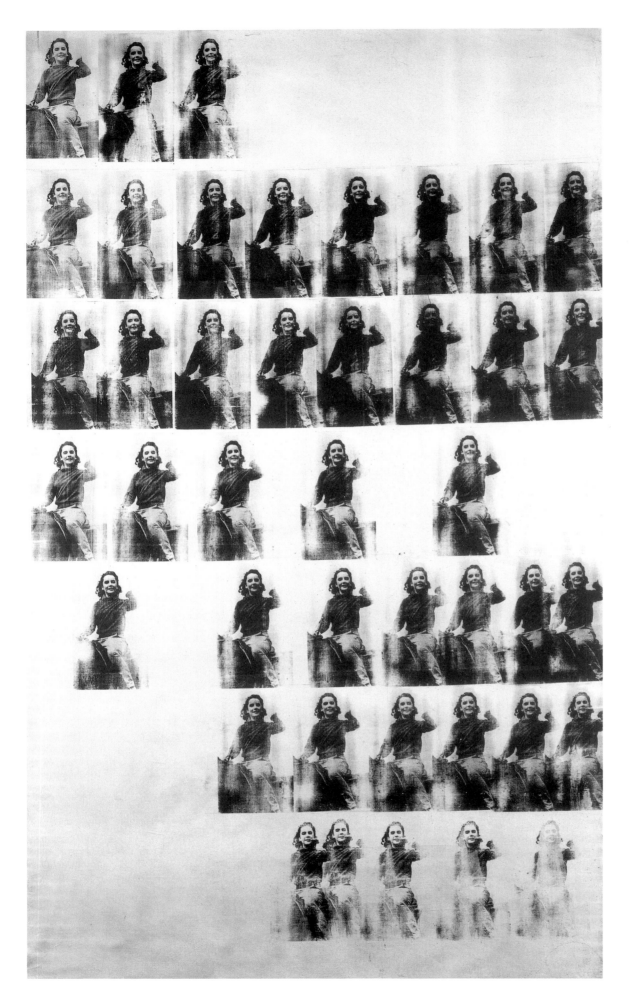

29 — NATIONAL VELVET 1963

74

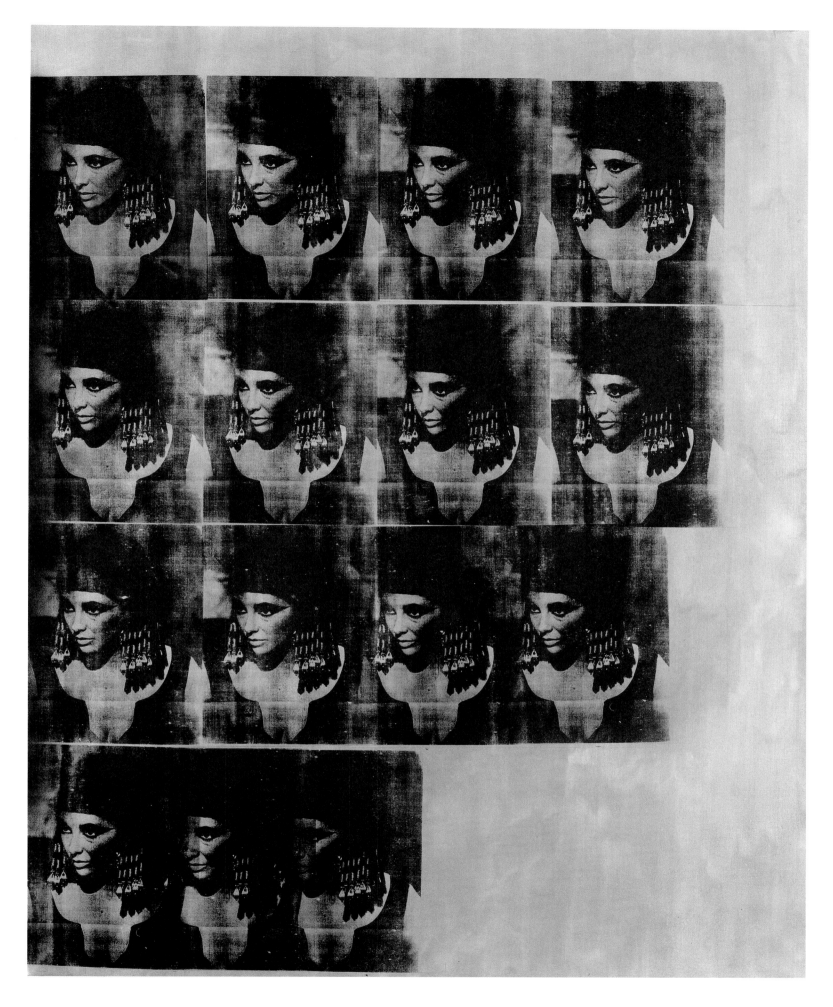

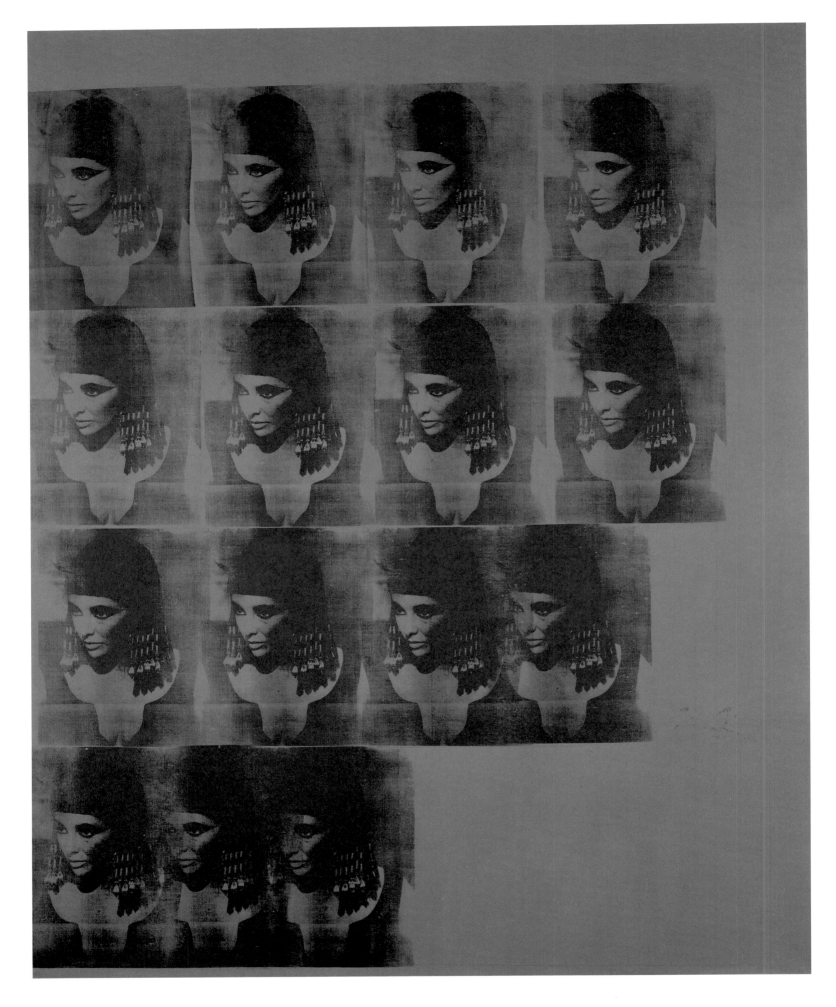

31—BLUE LIZ AS CLEOPATRA 1962

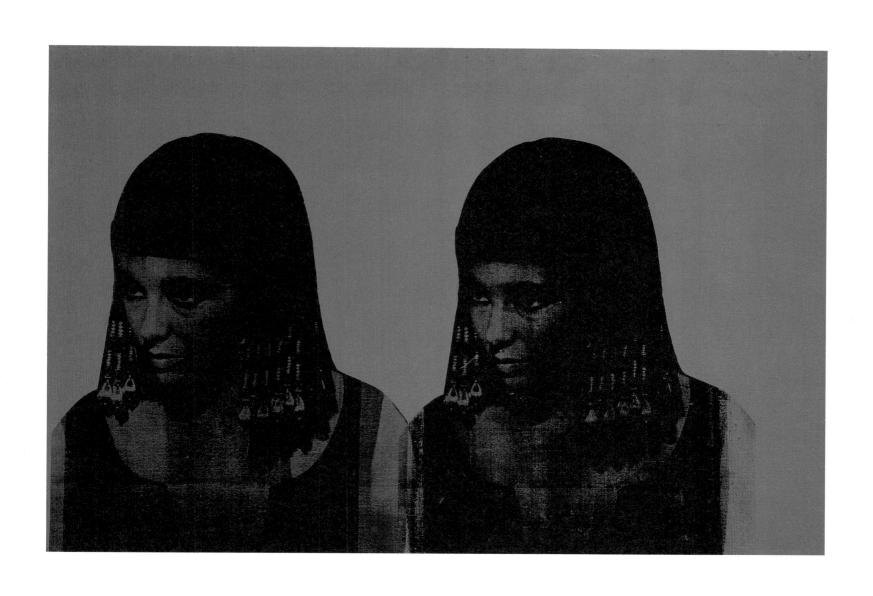

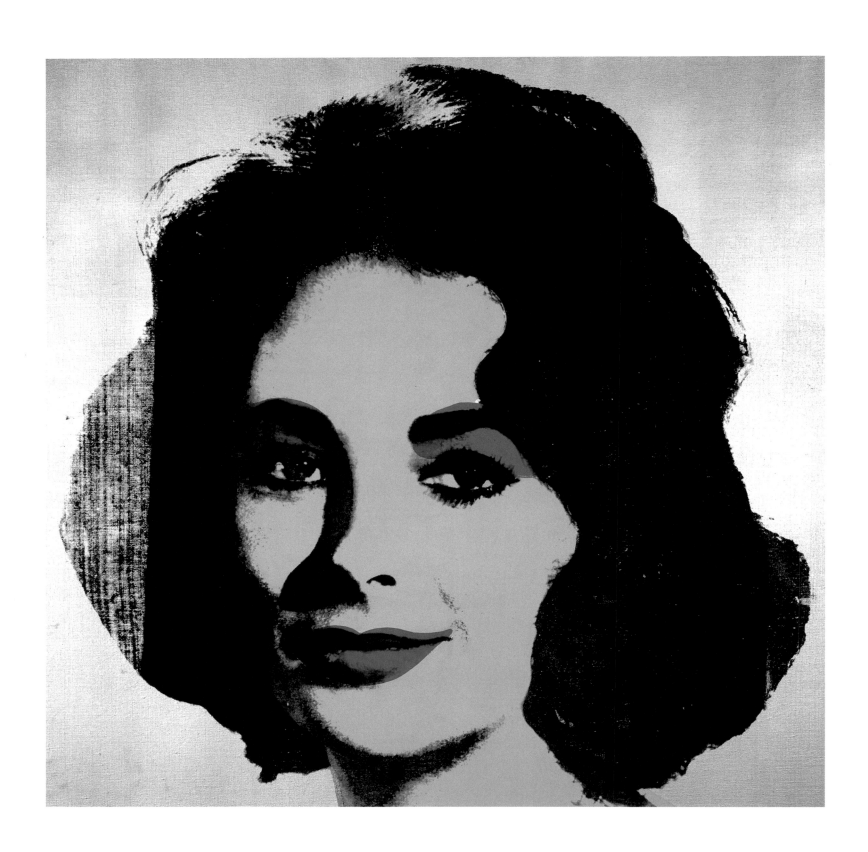

33 — SILVER LIZ 1963

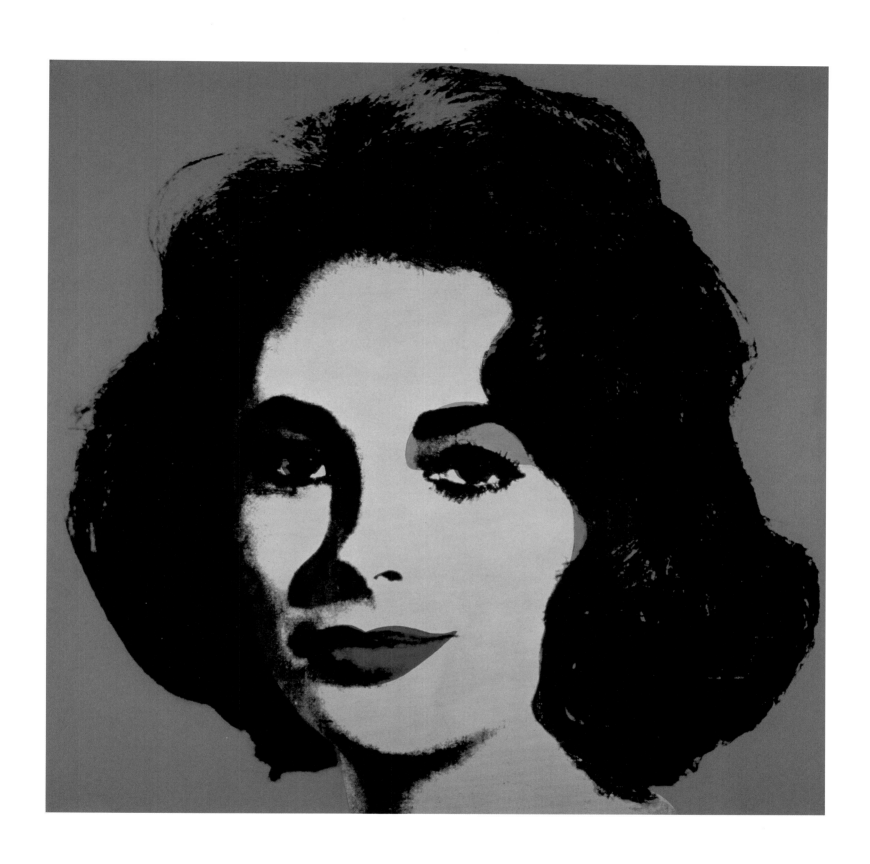

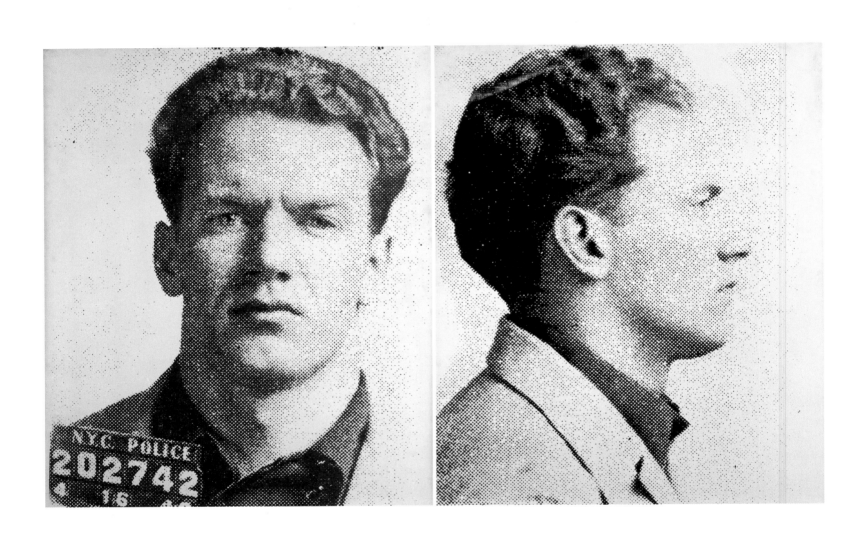

35 — MOST WANTED MEN NO. 6, THOMAS FRANCIS C. 1964

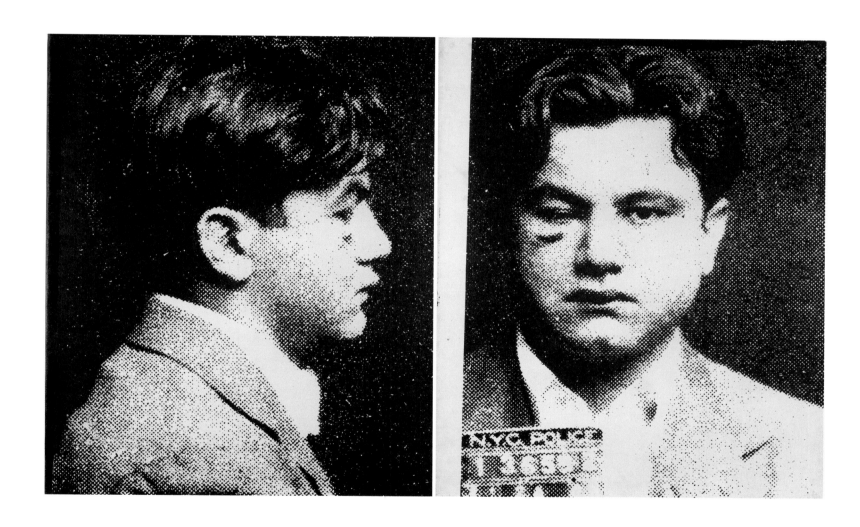

36 — MOST WANTED MEN NO. 2, JOHN VICTOR G. 1964

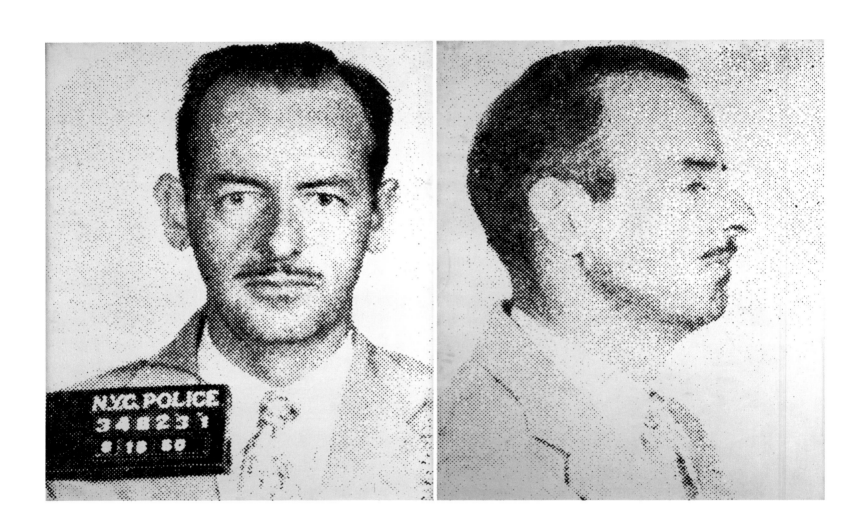

37 — MOST WANTED MEN NO. 5, ARTHUR ALVIN M. 1964

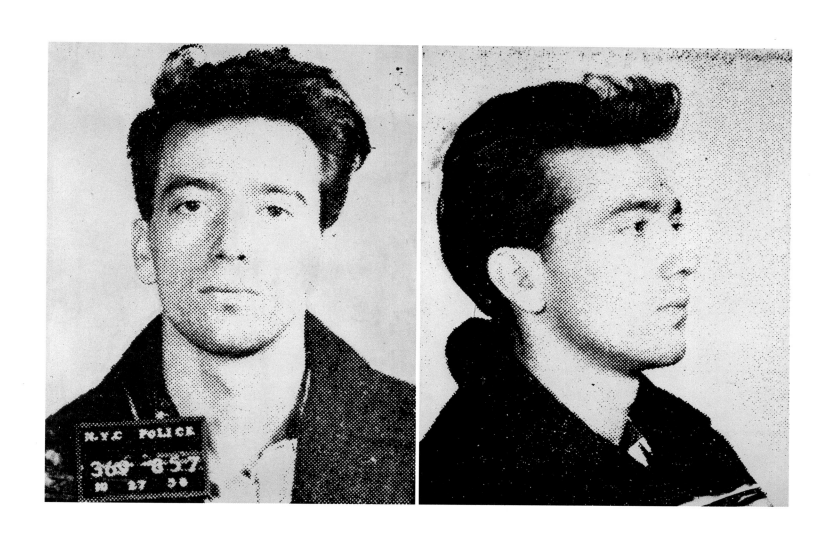

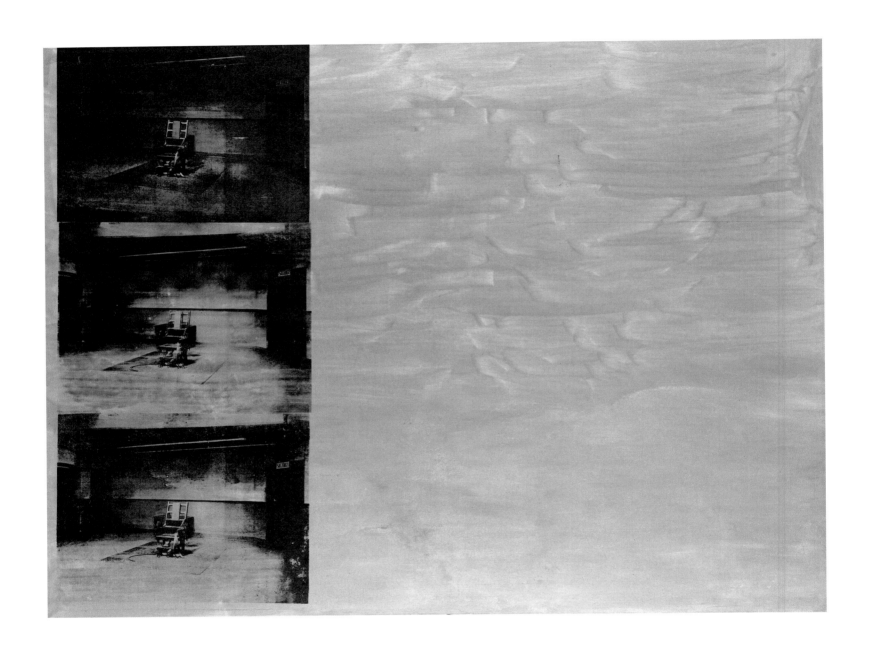

39 — TRIPLE SILVER DISASTER 1963

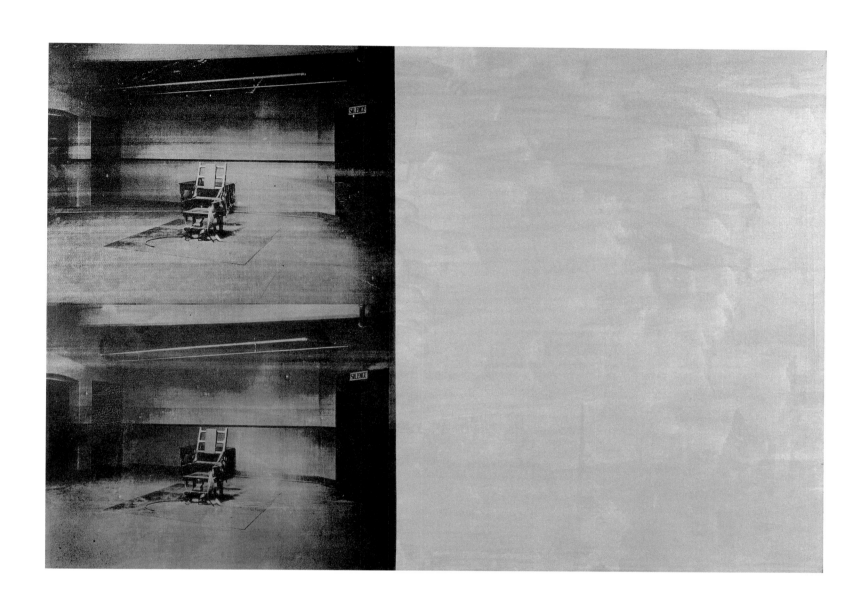

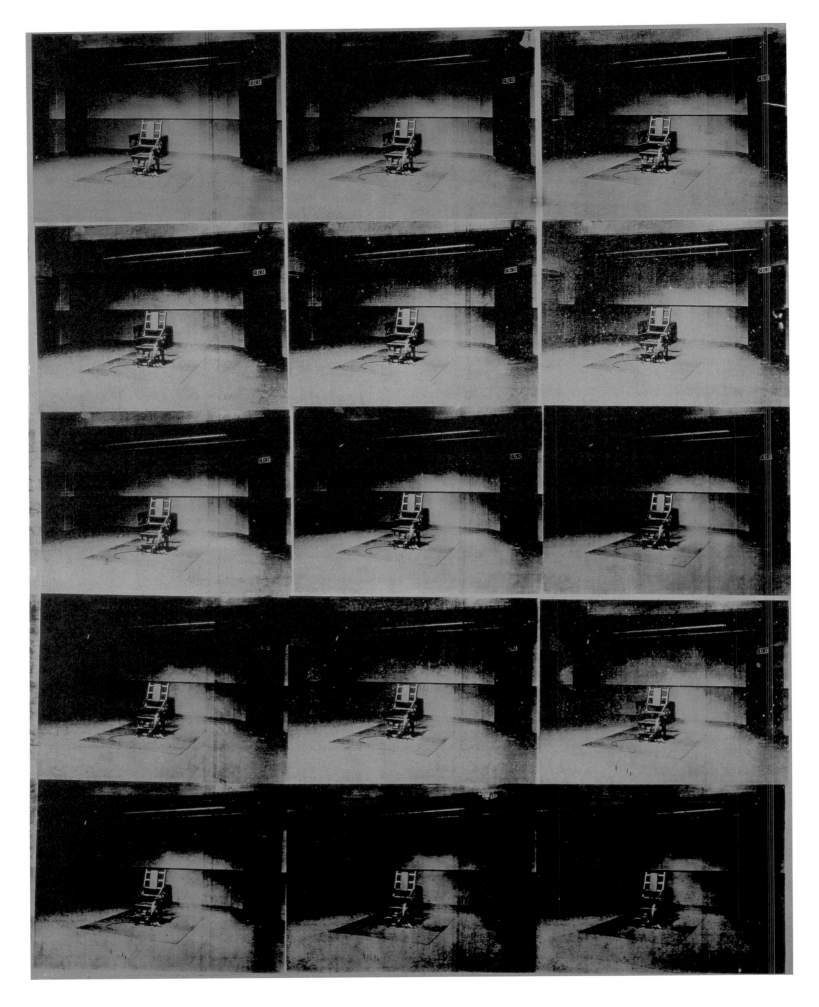

41—LAVENDER DISASTER 1963

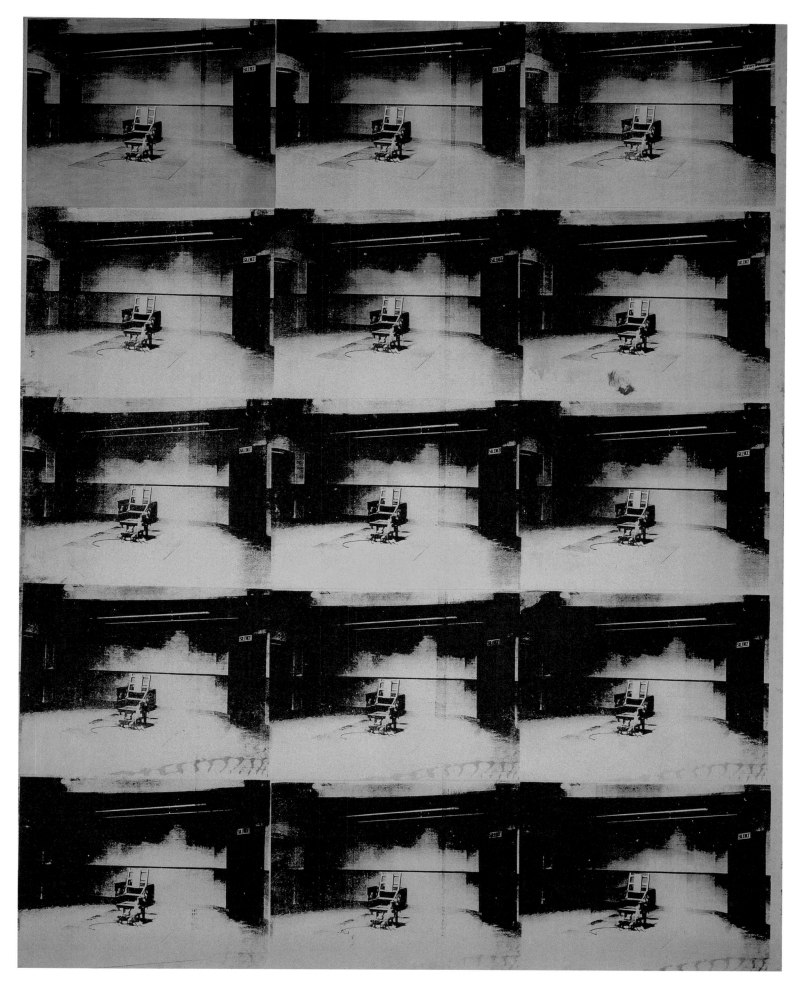

42—ORANGE DISASTER #5 1963

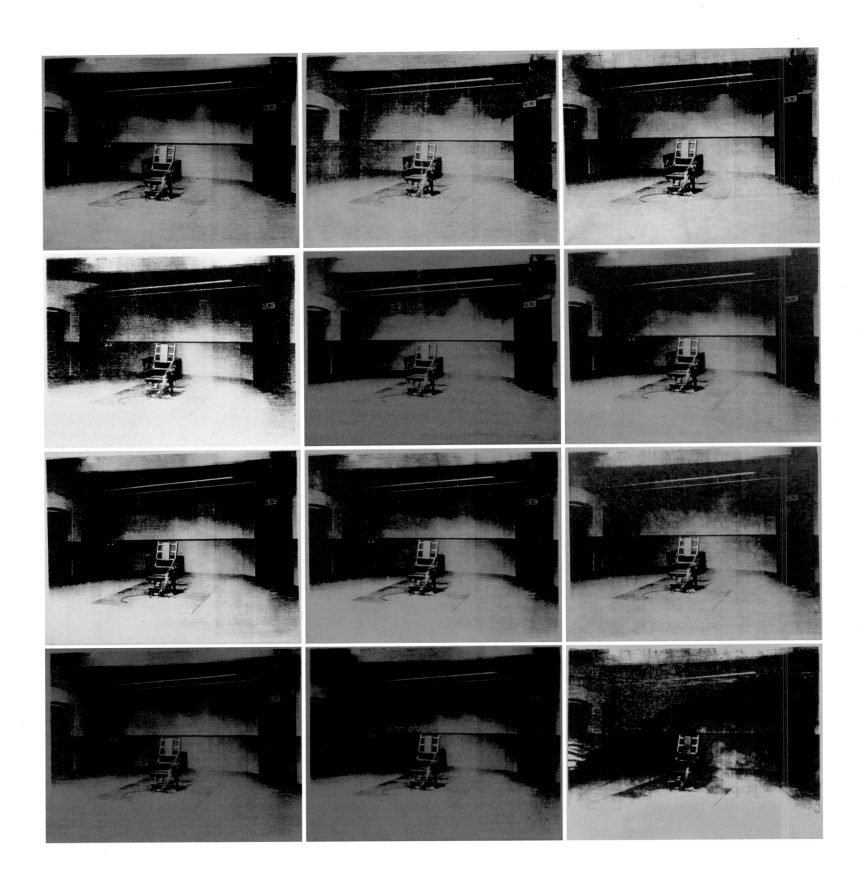

43 — TWELVE ELECTRIC CHAIRS 1964/1965

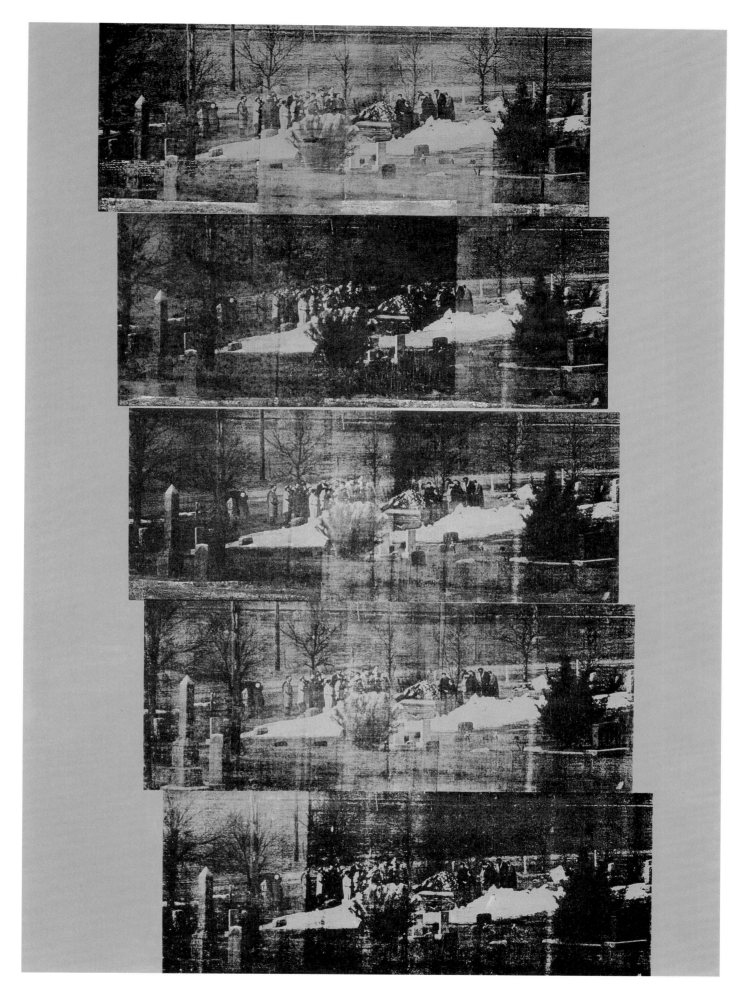

44—GANGSTER FUNERAL 1963

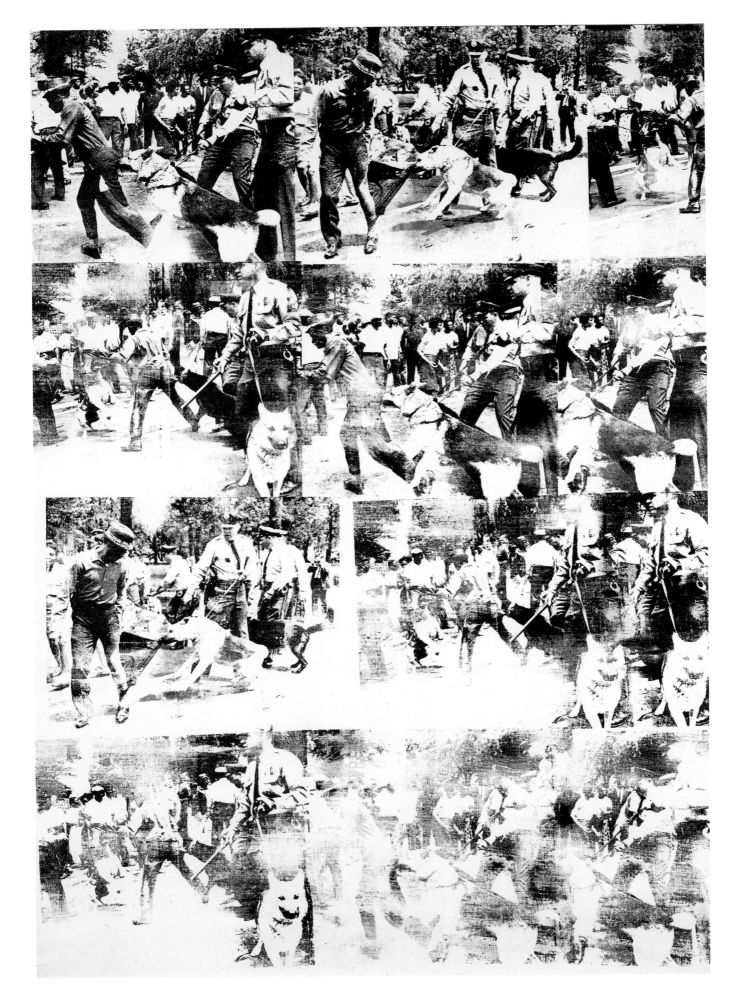

45 — RACE RIOT 1963

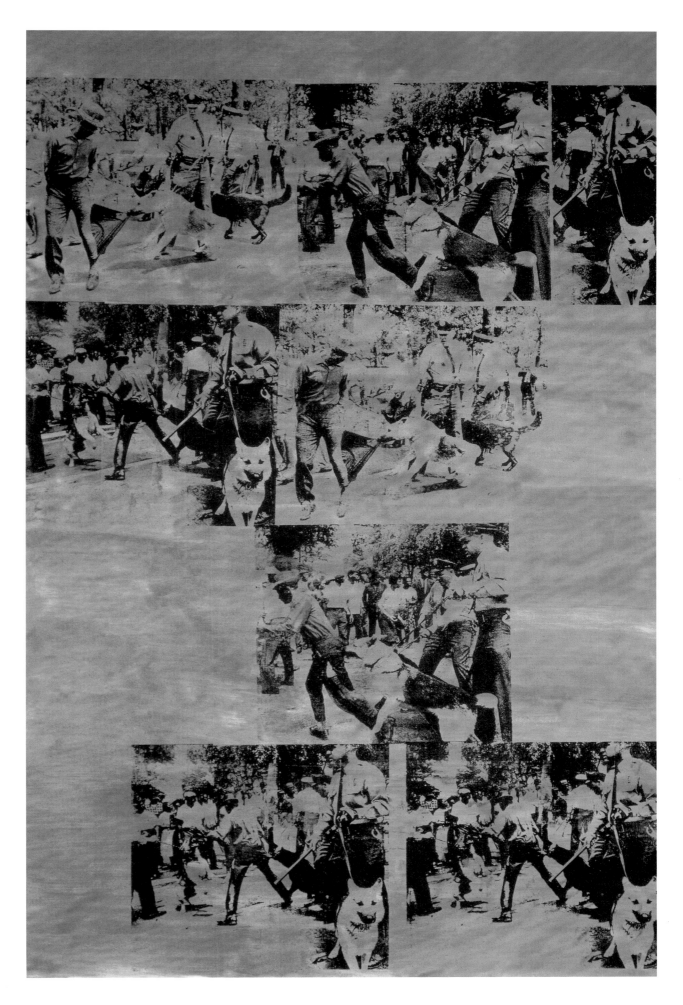

46 — PINK RACE RIOT 1963

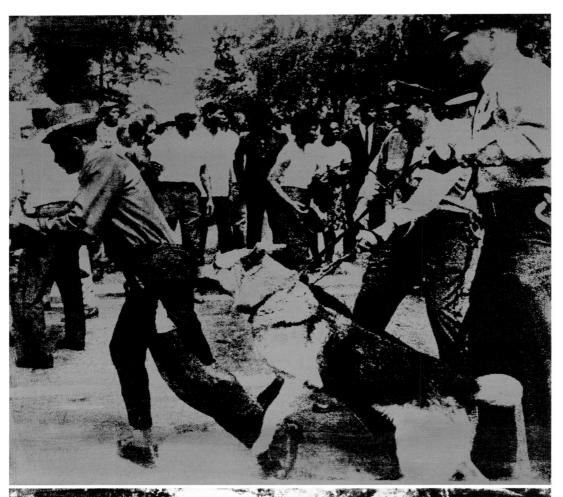

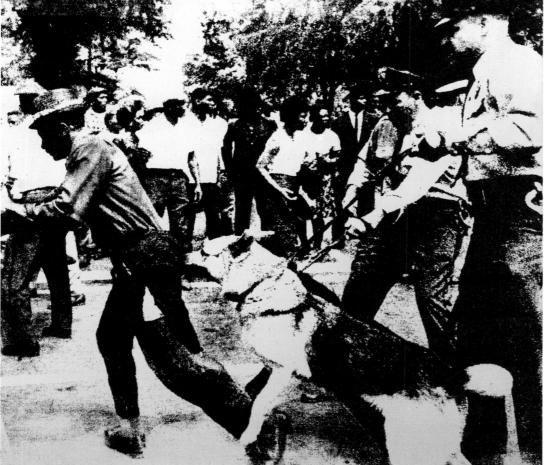

47 — LITTLE RACE RIOT 1964

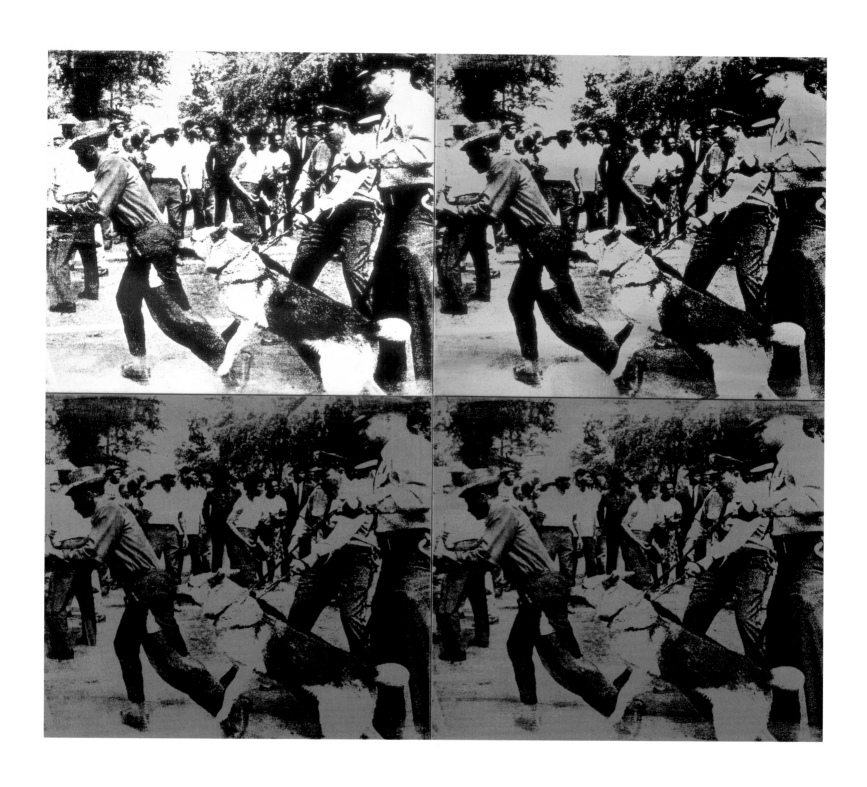

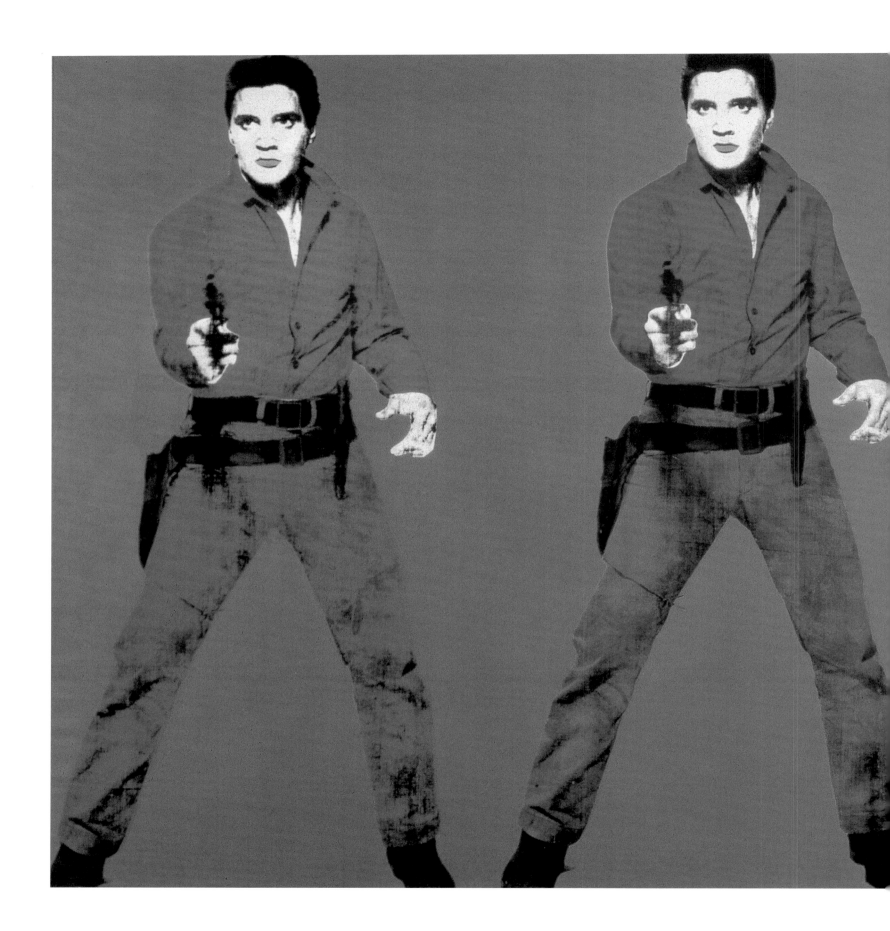

49—ELVIS I AND II 1963

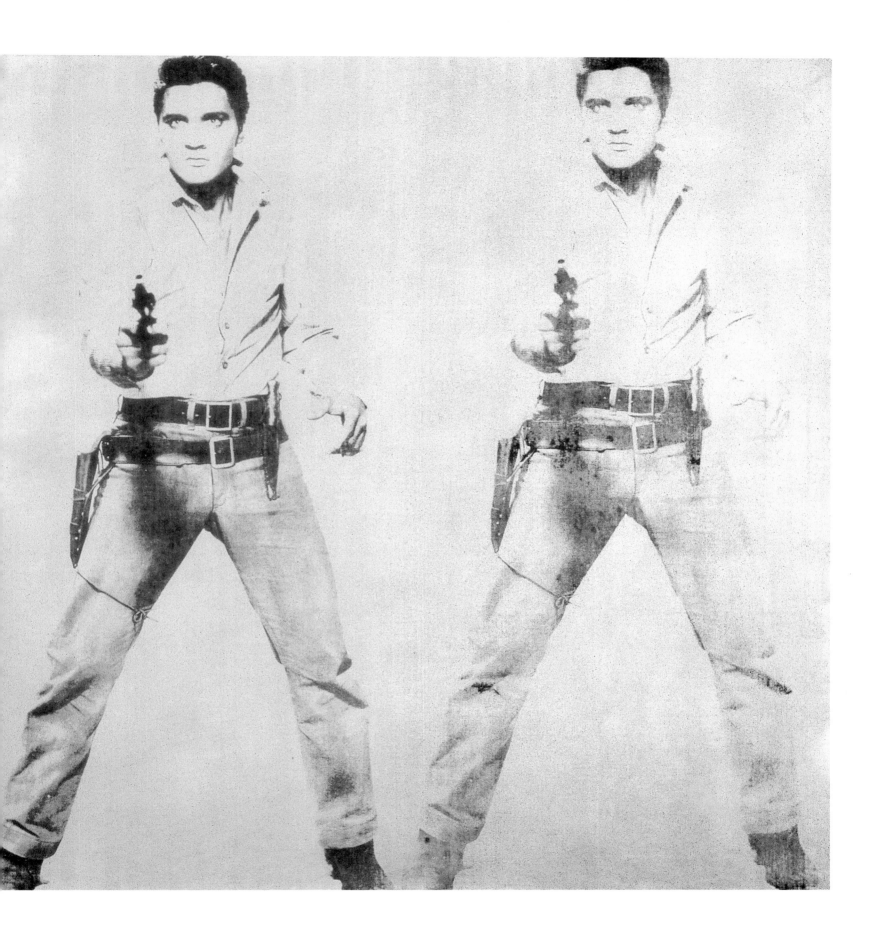

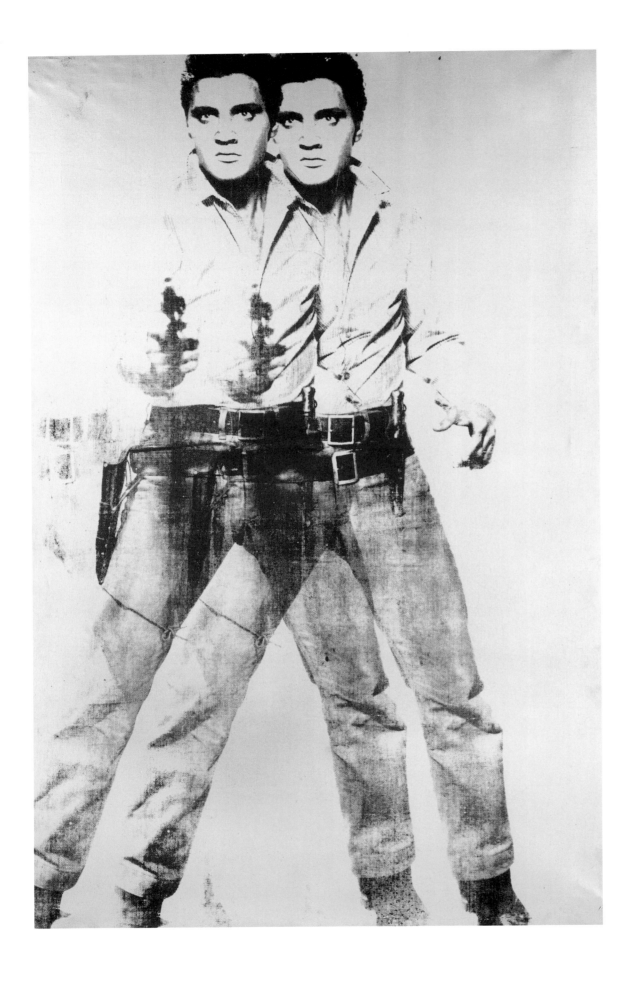

50 — DOUBLE ELVIS 1963

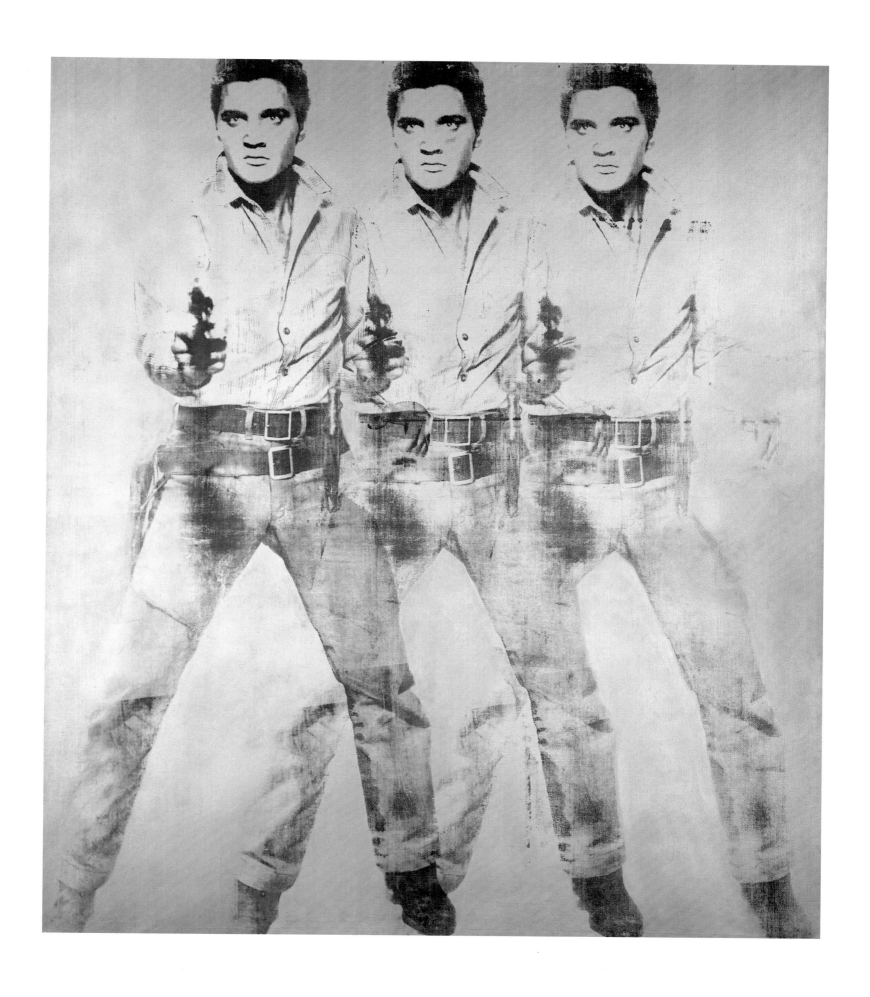

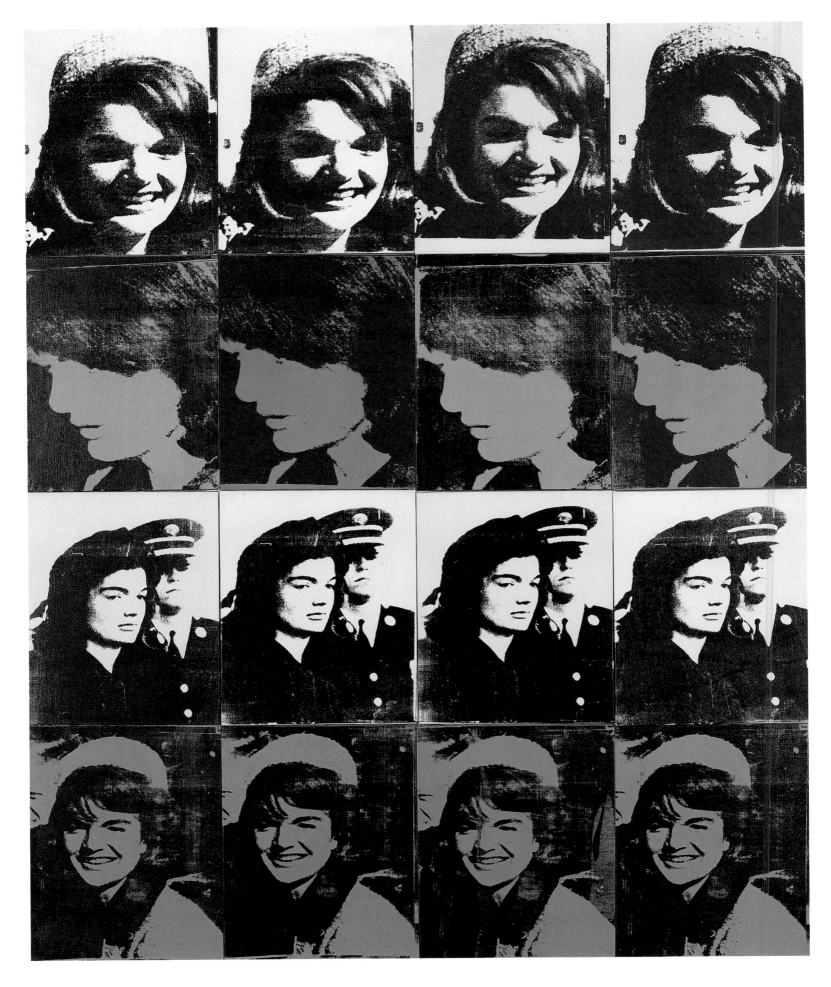

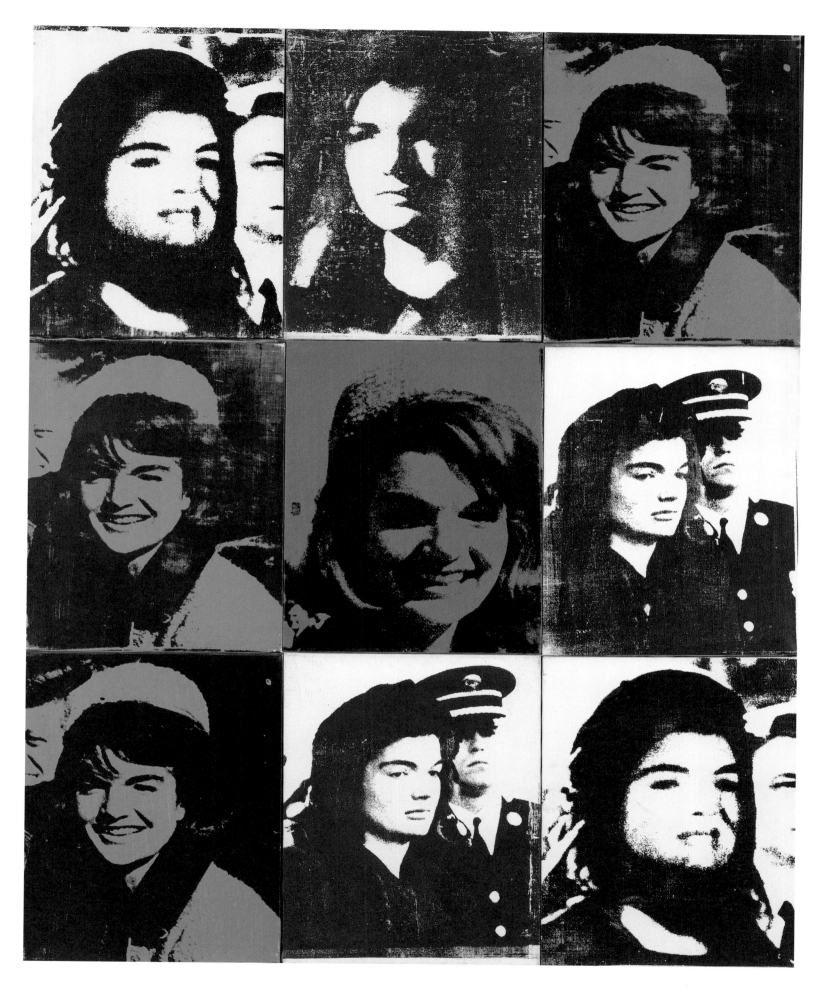

53— NINE JACKIES 1964

54 — JACKIE 1963

102

56 — JACKIE 1964

PLATE LIST

Works not included in the exhibition are indicated by an asterisk (°). This listing reflects the selection of works that will be shown in Minneapolis; some works that are listed as being in the exhibition will not be shown in Chicago and Toronto. In dimensions, height precedes width.

1—TURQUOISE MARILYN 1964
acrylic and silkscreen ink on linen
40 x 40 in. (101.6 x 101.6 cm)
Stefan T. Edlis, Chicago

2—MARILYN DIPTYCH 1962
acrylic, silkscreen ink, and pencil on linen
81 x 57 in. (205.7 x 144.8 cm) each of 2 panels
Tate, London

3—MARILYN MONROE'S LIPS 1962
acrylic, silkscreen ink, and pencil on linen
2 panels: 82 3/4 x 82 3/8 in. (210.2 x 209.2 cm) (black-and-white canvas); 82 3/4 x 80 3/4 in. (210.2 x 205.1 cm) (color canvas)
Hirshhorn Museum and Sculpture Garden, Smithsonian Institution, Washington, D.C; Gift of Joseph H. Hirshhorn, 1972

°4—NATALIE 1962
silkscreen ink on linen
83 x 89 1/8 in. (210.8 x 226.4 cm)
The Andy Warhol Museum, Pittsburgh. Founding Collection, Contribution the Andy Warhol Foundation for the Visual Arts, Inc.

°5—WARREN 1962
silkscreen ink and pencil on linen
81 1/2 x 83 in. (207 x 210.8 cm)
Private collection; courtesy Bruno Bischofberger, Zurich

°6—TROY 1962
silkscreen ink and acrylic on linen
14 x 11 in. (35.6 x 27.9 cm)
The Andy Warhol Museum, Pittsburgh. Founding Collection, Contribution the Andy Warhol Foundation for the Visual Arts, Inc.

7—TROY DIPTYCH 1962
silkscreen ink, acrylic, and pencil on linen
2 panels: 81 x 43 in. (205.8 x 109.3 cm) (color canvas); 81 x 67 3/4 in. (205.8 x 172 cm) (black-and-white canvas)
Museum of Contemporary Art, Chicago. Gift of Mrs. Robert B. Mayer

°8—A WOMAN'S SUICIDE 1962
silkscreen ink and pencil on linen
123 1/4 x 83 3/4 in. (313.1 x 212.7 cm)
Kunstsammlung Nordrhein-Westfalen, Düsseldorf

°9—SUICIDE (FALLEN BODY) 1963
silkscreen ink and silver paint on linen
112 x 80 1/4 in. (284.5 x 203.8 cm)
Private collection; courtesy Thomas Ammann Fine Art, Zurich

°10—BELLEVUE I 1963
silkscreen ink on canvas
106 x 83 in. (269.2 x 210.8 cm)
Private collection/ Kunstmuseum Liechtenstein, Vaduz

°11—SUICIDE (SILVER JUMPING MAN) 1963
silkscreen ink and silver paint on linen
141 1/2 x 79 1/2 in. (359.4 x 201.9 cm)
Daros Collection, Switzerland

12—GREEN DISASTER #2 1963
acrylic, silkscreen ink, and pencil on linen
107 1/3 x 79 1/8 in. (272.6 x 201 cm)
Museum für Moderne Kunst, Frankfurt

13—ORANGE CAR CRASH 1963
acrylic and silkscreen ink on linen
86 1/2 x 82 1/4 in. (219.7 x 208.9 cm)
GAM, Galleria Civica d'Arte Moderna e Contemporanea, Turin

14—FIVE DEATHS 1963
silkscreen ink and acrylic on linen
44 x 33 in. (111.8 x 83.8 cm)
Private collection

15—FIVE DEATHS 1963
silkscreen ink and acrylic on linen
35 x 33 in. (88.9 x 83.8 cm)
La Colección Jumex, Mexico

16—FIVE DEATHS ON ORANGE 1963
acrylic and silkscreen ink on linen
30 3/16 x 30 3/16 in. (76.7 x 76.7 cm)
The Sonnabend Collection, New York

17—FIVE DEATHS ON TURQUOISE 1963
silkscreen ink and acrylic on canvas
30 x 30 in. (76.2 x 76.2 cm)
The Sonnabend Collection, New York

18—FIVE DEATHS ON YELLOW 1963
acrylic and silkscreen ink on linen
30 1/8 x 30 1/8 in. (76.5 x 76.5 cm)
The Sonnabend Collection, New York

°19—ORANGE CAR CRASH FOURTEEN TIMES 1963
silkscreen ink, acrylic, and pencil on linen
2 panels: 105 7/8 x 82 1/8 in. (268.9 x 208.6 cm) (canvas with images); 105 5/8 x 82 in. (268.3 x 208.3 cm) (monochrome canvas)
The Museum of Modern Art, New York; Gift of Philip Johnson

°20—BLACK AND WHITE DISASTER #4 [FIVE DEATHS SEVENTEEN TIMES IN BLACK AND WHITE] 1963
acrylic, silkscreen ink, and pencil on linen
103 x 82 1/4 in. (262 x 209 cm) each of 2 panels
Kunstmuseum Basel

°21—WHITE DISASTER [WHITE CAR CRASH NINETEEN TIMES] 1963
silkscreen ink and pencil on primed linen
144 3/4 x 82 7/8 in. (367.7 x 210.5 cm)
Private collection

°22—SILVER CAR CRASH 1963
silkscreen ink and silver paint on linen
103 3/4 x 80 1/4 in. (263.5 x 203.8 cm)
Private collection

°23—WHITE BURNING CAR III 1963
silkscreen ink on linen
100 1/2 x 78 3/4 in. (255.3 x 200 cm)
The Andy Warhol Museum, Pittsburgh. Founding Collection, Contribution Dia Center for the Arts

24—SATURDAY DISASTER 1963–1964
silkscreen ink on linen
119 x 82 in. (302.3 x 208.3 cm)
The Rose Art Museum, Brandeis University, Waltham, Massachusetts; Gevirtz-Mnuchin Purchase Fund, by exchange

°25—AMBULANCE DISASTER 1963/1964
silkscreen ink on linen
124 1/2 x 79 7/8 in. (316.2 x 202.9 cm)
Staatliche Museen zu Berlin, Nationalgalerie, Collection Marx, Berlin

°26—FOOT AND TIRE 1963–1964
silkscreen ink on linen
80 x 145 in. (203.2 x 368.3 cm)
The Andy Warhol Museum, Pittsburgh. Founding Collection, Contribution Dia Center for the Arts

°27—BLACK AND WHITE DISASTER 1962
silkscreen ink and spray paint on linen
96 x 72 in. (243.8 x 182.9 cm)
Los Angeles County Museum of Art, Gift of Leo Castelli Gallery and Ferus Gallery through the Contemporary Art Council

28—TUNAFISH DISASTER 1963
silkscreen ink and silver paint on linen
124 1/2 x 83 in. (316.2 x 210.8 cm)
Daros Collection, Switzerland

29—NATIONAL VELVET 1963
silkscreen ink, silver paint, and pencil on linen
136 3/8 x 83 1/2 in. (346.4 x 212.1 cm)
San Francisco Museum of Modern Art. Accessions Committee Fund: gift of Barbara and Gerson Bakar, Doris and Donald G. Fisher, Evelyn and Walter Haas Jr., Mimi and Peter Haas, Byron R. Meyer, Helen and Charles Schwab, Danielle and Brooks Walker Jr., and Judy C. Webb; Albert M. Bender Fund; Tishler Trust; Victor Bergeron Fund; Members' Accessions Fund; and gift of The Warhol Foundation for the Visual Arts, Inc.

30—SILVER LIZ AS
CLEOPATRA 1963
silver paint, silkscreen ink,
and pencil on linen
82 x 65 in. (208.3 x 165.1 cm)
Art Gallery of Ontario,
Toronto. Gift of Mrs. Else
Landauer, in memory of her
husband, Walter Landauer,
1979

31—BLUE LIZ AS
CLEOPATRA 1962
acrylic, silkscreen ink, and
pencil on linen
82 1/4 x 65 in. (208.9 x
165.1 cm)
Daros Collection,
Switzerland

°32—DOUBLE LIZ AS
CLEOPATRA 1962
acrylic and silkscreen on
linen
21 1/8 x 31 1/4 in. (53.7 x
79.4 cm)
Private collection,
New York

°33—SILVER LIZ 1963
silkscreen ink, acrylic, and
spray paint on linen
40 x 40 in. (101.6 x 101.6 cm)
Private collection

°34—LIZ 1963
silkscreen ink and acrylic
on linen
40 x 40 in. (101.6 x 101.6 cm)
Irving Blum

35—MOST WANTED MEN
NO. 6, THOMAS FRANCIS C.
1964
silkscreen ink on linen
2 panels: 48 x 38 7/9 in.
(121.9 x 99 cm) (full face);
47 3/4 x 38 3/4 in. (121.3 x
98.4 cm) (profile)
The Eli and Edythe L.
Broad Collection

36—MOST WANTED MEN
NO. 2, JOHN VICTOR G.
1964
silkscreen ink on linen
48 1/2 x 38 5/s in. (123.2 x
98.1 cm) each of 2 panels
Daros Collection,
Switzerland

°37—MOST WANTED MEN
NO. 5, ARTHUR ALVIN M.
1964
silkscreen ink on canvas
47 1/2 x 38 7/8 in. (120.6 x
98.8 cm) each of 2 panels
Private collection

°38—MOST WANTED MEN
NO. 11, JOHN JOSEPH H.,
JR. 1964
silkscreen ink on linen
49 x 38 in. (124.5 x 96.5 cm)
each of 2 panels
Private collection; courtesy
Thomas Ammann Fine Art,
Zurich

°39—TRIPLE SILVER
DISASTER 1963
silkscreen ink and silver
paint on linen
63 5/s x 83 1/8 in. (161.6 x
211.1 cm)
Wadsworth Atheneum
Museum of Art, Hartford,
Connecticut. The Ella
Gallup Sumner and Mary
Catlin Sumner Collection

40—SILVER DISASTER #6
1963
silkscreen ink, silver paint,
and spray paint on linen
42 x 60 in. (106.7 x 152.4 cm)
The Sonnabend Collection,
New York

41—LAVENDER DISASTER
1963
acrylic, silkscreen ink, and
pencil on linen
106 x 81 7/s in. (269.2 x 208 cm)
The Menil Collection,
Houston

°42—ORANGE DISASTER #5
1963
acrylic, silkscreen ink, and
pencil on linen
106 x 81 3/4 in. (269.2 x
207.6 cm)
The Solomon R. Guggen-
heim Museum, New
York, Gift of the Harry N.
Abrams Family Collection
N.Y., 1974

43—TWELVE ELECTRIC
CHAIRS 1964/1965
silkscreen ink and acrylic
paint on canvas
22 x 28 in. (55.9 x 71.1 cm)
each of 12 panels
The Stephanie and
Peter Brant Foundation,
Greenwich, Connecticut

°44—GANGSTER FUNERAL
1963
silkscreen ink, acrylic, and
pencil on linen
105 x 75 5/s in. (266.7 x
192.1 cm)
The Andy Warhol Museum,
Pittsburgh. Founding
Collection, Contribution
Dia Center for the Arts

45—RACE RIOT 1963
silkscreen ink on linen
120 3/4 x 83 in. (306.7 x
210.8 cm)
Daros Collection,
Switzerland

46—PINK RACE RIOT [RED
RACE RIOT] 1963
silkscreen ink and acrylic
on linen
128 1/4 x 83 in. (325.8 x
210.8 cm)
Museum Ludwig, Cologne.
Ludwig Donation

°47—LITTLE RACE RIOT 1964
acrylic and silkscreen ink
on linen
30 x 33 in. (76.2 x 83.8 cm)
each of 2 panels
Stephan T. Edlis, Chicago

°48—LITTLE RACE RIOT
1964
acrylic and silkscreen ink
on linen
30 x 33 in. (76.2 x 83.8 cm)
each of 4 panels
Private collection, Monte
Carlo

49—ELVIS I AND II 1963
silkscreen ink and spray
paint on linen (silver
canvas); silkscreen ink
and acrylic on linen (blue
canvas)
82 x 82 in. (208.3 x 208.3)
each of 2 panels
Art Gallery of Ontario.
Gift from the Women's
Committee Fund, 1966

°50—DOUBLE ELVIS 1963
silkscreen ink and silver
paint on linen
82 x 52 in. (208.3 x 132.1 cm)
Jerry and Emily Spiegel
Family Foundation

°51—TRIPLE ELVIS 1963
silkscreen ink, silver paint,
and spray paint on linen
82 x 72 in. (208.3 x 182.9 cm)
Virginia Museum of Fine
Arts, Richmond, Virginia.
Gift of Sydney and Frances
Lewis

52—SIXTEEN JACKIES 1964
acrylic and silkscreen ink
on linen
80 3/s x 64 3/s in. (204.2 x
163.5 cm)
Collection Walker Art
Center; Art Center
Acquisition Fund, 1968

53—NINE JACKIES 1964
acrylic and silkscreen ink
on linen
60 7/s x 48 3/4 in. (154.6 x
123.8 cm)
The Sonnabend Collection,
New York

°54—JACKIE 1963
acrylic and silkscreen ink
on canvas
20 x 16 in. (50.8 x 40.6 cm)
Collection of Marla and
Larry Wasser, Toronto

°55—JACKIE 1964
synthetic polymer paint and
silkscreen ink on canvas
20 x 16 in. (50.8 x 40.6 cm)
Private collection, Toronto

°56—JACKIE 1964
acrylic and silkscreen ink
on linen
20 x 16 in. (50.8 x 40.6 cm)
The Andy Warhol
Foundation for the Visual
Arts, Inc., New York

REPRODUCTION CREDITS

SPONSOR'S STATEMENT

Northern Trust

Since its founding in 1889, Northern Trust has advanced a culture of caring and a commitment to invest in the communities we serve. A large part of our investment is through charitable donations and corporate sponsorships. Northern Trust is proud to sponsor *ANDY WARHOL/SUPERNOVA: Stars, Deaths, and Disasters, 1962–1964* and to provide an opportunity for thousands of guests to experience examples of Andy Warhol's earliest photo-silkscreen serial paintings, which in effect created a whole new art form: American Pop.

Creativity is synonymous with Andy Warhol. Creativity is also an attribute we employ every day in our business to better understand, plan for, and help ensure our clients' financial goals.

We applaud the Walker Art Center in Minneapolis, the Museum of Contemporary Art in Chicago, and the Art Gallery of Ontario in Toronto for their collaboration in bringing this one-of-kind exhibition to thousands of art enthusiasts in the United States and Canada. On behalf of Northern Trust, I invite you to enjoy this important exhibition—the work of Andy Warhol, one of the most influential artists of the second half of the twentieth century.

William A. Osborn
Chairman and Chief Executive Officer
Northern Trust Corporation